Conserving Old Masters

Dulwich Picture Gallery, London, 1995

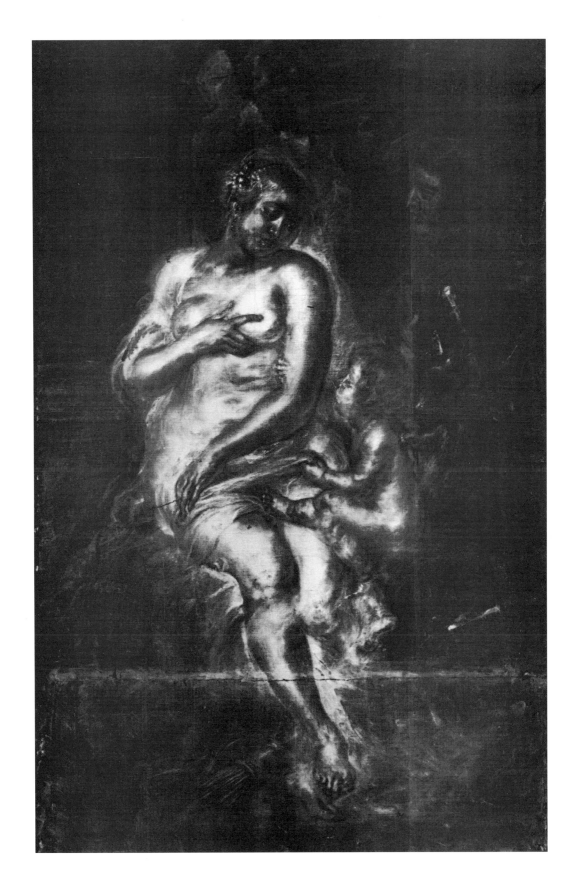

Conserving Old Masters

Paintings Recently Restored at Dulwich Picture Gallery

Contents

Preface

This catalogue and exhibition are intended to record, and to celebrate, the conservation work that has been carried out on a number of important paintings at Dulwich Picture Gallery. The Gallery has an old and rich collection, and until recently had effectively no budget with which to conserve it. Although a programme of conservation was carried out immediately after the Second World War, by the late 1980s it was clear that a number of paintings in store required urgent consolidation, and that many of the major works would also benefit from treatment. Raising money for conservation became an urgent task, and I am happy to say that it was a cause to which donors responded with great generosity.

My first thanks must go to the Getty Grant Program for the sustained help and encouragement that they have given to us at Dulwich Picture Gallery over the past six years: firstly in fully supporting a complete survey of the collection, ably carried out by Patrick Lindsay; secondly in making matching grants for the conservation of the twelve pictures included in this catalogue; and thirdly for their sponsorship of this exhibition. It has been a great pleasure and privilege to work with such discriminating, occasionally demanding, but always supportive, donors as the officers of the Program. On behalf of the trustees of the Gallery, I am delighted to express my thanks to Charles J. Meyers and Timothy P. Whalen, Senior Program Officers and above all the Program's Director, Deborah Marrow.

A considerable number of conservators have worked on the paintings shown in this exhibition, and I am most grateful to them all both for the work they have carried out and for their helpfulness in contributing to this catalogue. I am very pleased to acknowledge the skill that they have given to working on this enterprise. In particular I wish to thank Patrick Lindsay, for his greatly valued contributions to conservation at Dulwich over several years and Sophia Plender, Consultant Conservator at the Gallery since 1989, for the enormous help that she has given over a wide variety of problems in these past years. For this catalogue, a number of art historians have generously provided contributions, and I am most grateful to Xanthe Brooke, Alan Chong and Michael Jaffé.

Over the years the Gallery has received very substantial help from a number of other sources for conservation, and I would particularly like to thank the trustees of the Monument Trust for the consistent support that they have given to the Gallery; and the Friends of the Gallery for their generous support of a number of important conservation projects over the past seven years. Our popular Picture Adoption Scheme has also provided very substantial help with conservation of both pictures and frames.

In preparing this exhibition I am greatly indebted to the work of all the staff at the Gallery, especially Stephen Atherton, Victoria Bethell, Sheila Gair, Kate Knowles, Charles Leggatt, Tom Proctor, Peter Theobald, Julian Spicer, Ann Sumner, Lucy Till, and above all Richard Beresford, who immediately on his appointment as curator here found himself faced with the duty of organising this exhibition, and threw himself into the task with the full vigour, intelligence and awareness that it required.

Giles Waterfield
Director, Dulwich Picture Gallery

Giles Waterfield

Conservation at Dulwich Picture Gallery 1811–1995

Shortly before his death in 1811 Sir Francis Bourgeois, founder of Dulwich Picture Gallery, explained to the Master of Dulwich College, who was about to receive the collection on behalf of his foundation, how he wanted his pictures to be looked after. A survey of the collection was to be made once a year by the President of the Royal Academy '& one or two Persons skilled in the Arts, who could point what Pictures wanted cleaning'. According to the account written by the Master, and preserved at Sir John Soane's Museum, 'He said from long experience I know pretty well what will be the expense on the average of havingthem cleaned, it will be about 100 a year'. The annual visit of the Royal Academicians to Dulwich, a tradition which lasted well into the twentieth century, was intended to give them an opportunity to discuss the conservation policies of the Gallery, though in reality these visits soon became more social than professional. The inclusion of this visit in Bourgeois' conditions for the care of his collection illustrates the continuance of the long-established and intimate connection between painters and picture conservation.

Bourgeois had himself been in the habit of working on the paintings in his possession, which he sometimes 'improved' according to his own ideas: the Teniers *Peasants Conversing* (No. 5) with its substantial additions, would seem on the evidence of the brushwork in the added portions to represent an example of this, to us, cavalier approach – an approach which to people of Bourgeois' generation reflected a sense of continuity between painters, and paintings, of the present and the past, allowing works inherited from earlier periods to be adapted to modern needs. The association with a living artistic tradition was maintained by Stephen Poyntz Denning, the Keeper of the Gallery from 1821 to his death in 1864. Denning was an accomplished artist (his best-known work is the little *Princess Victoria* at Dulwich), and his employment at Dulwich was characteristic of the nineteenth-century custom of employing painters as curators of art museums, and requiring them in many cases to look after the physical well being of the works in their care: the Directors of the National Gallery were all painters until the early twentieth century,

though they were not generally expected to act as restorers. Although Denning did not record his activities in this area he would have retouched paintings and regularly revarnished them. This approach was maintained by his successor, T. F. Hodgkins, an artist of outstandingly little talent. Hodgkins's treatment was limited to the regular application of linseed oil to the paintings which were then 'carefully rubbed with a soft cloth'. As expert observers remarked, Hodgkins's plan was 'conservative rather than ameliorative', and he carried out his duties in a most conscientious manner.

In the 1850s the constitution of the College was reformed, being placed in the hands of a Board of Governors, and the present College buildings were erected to the designs of Charles Barry Junior. In place of the *laissez-faire* approach of earlier generations, a more professional attitude was also taken to the care of the Gallery. Already in March 1858 a survey was made for the College by Richard Redgrave of the art department of the South Kensington Museum, a painter and one of the outstanding arts administrators of his day. He recommended that more professional care should be given to the pictures, many of which ought to be revarnished, that their backs should be protected with 'a light painted cloth', and that care should be given to the better lighting of the Gallery. Soane's top lighting with its low monitor lights and numerous glazing bars had come to seem inadequate.

Relatively little attention seems to have been paid to the recommendations of Redgrave's report, and a further survey by J.C. Robinson, Curator at the South Kensington Museum, was presented to the Governors in June 1865. Robinson remarked that 'the best pictures at Dulwich are in the best preservation' owing to the superior care they had received. He felt that while they had 'escaped damage from the active operations of the picture cleaner and restorer, they have, perhaps, on the other hand, to some extent suffered from neglect and that timidity and over-scrupulousness, which a strong sense of responsibility engenders.' Robinson made a number of practical recommendations: the pictures should be tapped out and given additional protection, both by glazing and by the application of canvas

backings to prevent the accumulation of dirt behind the pictures. Expressing his reservations about the process of restoration and writing with 'the greatest caution and reserve', he noted that many of the paintings had become '"chilled"' (by which he presumably meant that they had blanched – it is a problem which continues to affect the collection) and that some removal of varnish might be necessary. He also felt that in some cases the pictures should be relined, although he expressed grave doubts about the damage that this process could inflict. Only two pictures were singled out by Robinson as in need of immediate attention.

Following Robinson's report, care of the collection was more actively taken in hand. Many of the paintings were 'revived and varnished', presumably by Hodgkins, to the satisfaction of Sir William Boxall, Director of the National Gallery, who visited in 1871. Much work was also carried out on regilding the frames, and this work seems to have been completed by the early 1880s. In 1876 the collections of Edward Alleyn and William Cartwright which had belonged to Dulwich College since the seventeenth century were transferred to the Gallery. These had been heavily worked on between 1810 and 1818 by a Robert Browne who sent in a number of bills for 'Lining Cleaning Stipling &c'. Browne appears in many cases to have repainted the pictures in a bold and colourful style.

In the 1910s and 1920s a further programme of conservation was carried out, with the paintings being sent for treatment to the well-known West End firms of Holder's and H. Reeve and Son, firms also used by the National Gallery at a time when conservators were unknown on the permanent staff of museums. 'Scholarly' picture conservation of the type now recognised did not exist at the time in Britain: not until the 1930s did the influence of German restorers transform attitudes to assessing and recording the treatment of paintings. Considerable alarm was caused at Dulwich in 1934 by the discovery of an outbreak of wood-worm in the furniture and the frames and stretchers of the paintings. But traditional practices were maintained. In 1934 the Keeper, Mr. New, recorded that over the past 44 years he had regularly 'revived' the pictures with a mixture of mastic varnish, linseed oil and turpentine, a practice that he still maintained.

During the Second World War the collection was mostly stored in a quarry in Wales, with the National Gallery's holdings: a few large pictures that were left behind were damaged or destroyed by the bomb of 1944. On their return from Wales they were examined by the painter Sir Gerald Kelly, President of the Royal Academy and Governor of Dulwich College, and by Anthony Blunt, who together made artistic decisions at the Gallery at this time. It was decided to entrust the whole of the collection to Dr. Hell, a German art

historian and picture restorer living in London. From 1945 to 1970 almost all the paintings in the collection passed through his studio: in many instances they received full conservation treatment, though in the manner of the time no record was kept of the work carried out. By today's standards, this important campaign was carried out in a somewhat lax manner curatorially: a group of pictures would be put in a taxi and despatched *en masse* to Hampstead. Once in the studio, if they were felt to be of lesser importance they might remain there for up to twenty years, while a number of paintings which were thought to be unworthy of exhibition were abandoned half way through the process of cleaning and left unrestored. At the same time, much thought was given to providing suitable atmospheric conditions in the Gallery, and when it was rebuilt in the years up to 1952 an air circulation system which was thought advanced at the time was installed (though possibly the practice of turning it off at night to save money reduced its effectiveness). It continued to function, in an increasingly erratic manner, until the late 1980s. Hell's work was continued by the English restorer, John Brealey, who subsequently moved to become Head of Conservation at the Metropolitan Museum, New York, but by this time the Gallery, which was being run on an absurdly tight budget, was unable to afford more than very occasional expenditure.

In the late 1970s the Governors of Dulwich College decided that the collection in their care must be looked after on a more professional basis. As part of the national policy of regarding national museums as 'centres of excellence' with a brief to assist their less privileged fellows, the Conservation Department of the National Maritime Museum was asked in 1978 to advise on the care of the collection. They introduced many improvements in the maintenance of the collection, in addition to restoring a number of paintings for no charge. The need for financial stringency in national museums inevitably brought an end to this generous policy in 1986.

During the late 1980s the Gallery remained seriously under-funded, though it received continuous support from the Friends of Dulwich Picture Gallery. A conservation appeal held in 1988–90 allowed the installation of an up-to-date air-conditioning system. At the same time various programmes, notably the Picture Adoption Scheme, were introduced to raise money for conservation. Support from the Getty Grant Program allowed a survey of the entire collection to be carried out in 1988–90 by Patrick Lindsay, and the resulting report has formed the basis of the Gallery's conservation policy since that time. The survey emphasised the need for structural work to be carried out on a number of paintings, and particularly the urgent obligation to conserve many of the unexhibited paintings kept in store, to which little attention had been given. Sophia Plender was appointed to the position of Consultant Conservator in 1989. The programme of work on the store has now been largely completed, with several pictures which had not been shown for many years being put on permanent display as a result. A significant number of paintings on general view have also been conserved with the help of the Getty Grant Program, the Monument Trust and other generous donors.

11

David Bomford

Perceptions of Picture Conservation

The cleaning of a great painting naturally excites interest and debate. When a whole group of important paintings in a small, famously coherent collection such as Dulwich is restored, it is a notable event.

The impact of such an event is greater than the sum of its parts, for what we see are not just individual works of art transformed by the conservator's skill but their interactions with each other and with the other works that surround them. It is a well-known phenomenon that a single cleaned painting in an otherwise untouched collection leaps to the eye for all the wrong reasons: not for its quality or brilliance of execution, but by simple principles of contrast. It is equally well-known that some observers will be drawn to the cleaned picture in admiration of its new-found clarity and freshness, while others will be dismayed at what they see as its unnatural brightness.

The roots of this dichotomy are very ancient indeed. Paintings have been cleaned with varying success for almost as long as they have been created. Recipes for 'washing' pictures exist in documentary sources of the sixteenth century and probably earlier; some warn of possible dangers in the process, while others do not. Similarly, the restoration of paintings has been practised for as long as they have been susceptible to damage. A famous passage in Vasari's life of Signorelli tells us how the *Circumcision* of 1491 became damaged by damp and how the Child was repainted by Sodoma: Vasari complained that the Child was now much less beautiful than before and went on, 'in truth it would sometimes be better to leave works half spoiled when they have been made by men of excellence, than to have them retouched by inferior masters.' Vasari's disapproval was no doubt coloured by his obvious dislike of Sodoma – but it is interesting as one of the first recorded opinions of the outcome of a particular restoration.

Through the nineteenth and twentieth centuries other opinions have been forcibly expressed at regular intervals concerning the cleaning of paintings, both for and against. It would seem to be instructive now, as the recently restored paintings from Dulwich are once again celebrated in their familiar surroundings, to examine late twentieth-century perspectives on this recurring theme.

The fact that cleaning and restoration are often simultaneously praised and criticised alerts us to the idea that perceptions of the process may vary widely. In fact, we can identify a range of viewpoints between and beyond the polarities of criticism and admiration. Considerations surrounding the treatment of paintings extend much further than simple assessments of gain or loss. We might ask how newly conserved paintings are perceived by different observers: whether conservators and conservation scientists see the treatment of paintings in the same way as curators and art-historians. We might also consider the impact of cleaned pictures on the gallery-going public, why the cleaning of paintings arouses controversy and the role of sponsors in making conservation treatments possible.

The conservator or restorer who works on a painting is concerned in the first instance with preservation and stabilisation – hence the modern substitution of the term 'conservation' for 'restoration', implying long-term care of an entire work of art rather than surface treatment alone. The majority of the twelve pictures chosen for treatment here were in need of structural repair, to correct flaking paint and replace old and perished linings. That these are standard procedures does not in any way lessen their importance or the skill and sensitivity with which they must be carried out. A conservator can only clean and restore a painting successfully once it is structurally secure.

Although structural conservation is concerned with physical and mechanical processes, the conservator should never lose sight of the significance of the work of art itself. A painting is, of course, a material assembly of great physically complexity, subject to various kinds of deterioration, but it is also an organic document providing information about the manner of its making and the circumstances of its survival. Above all it is the product of a culture, an intellect and a hand that, taken together add up to something that transcends material description.

All this has to coexist in the mind of the conservator with more straightforward choices and decisions about treatment. Indeed they are inseparable: every step the conservator takes must

be informed by considerations of original materials and technique, subsequent alterations, both natural and man-made and, most importantly, the artist's intent. What effects will structural treatment, varnish removal or restoration of damages have on the documentary and aesthetic qualities intrinsic to the work of art? How far can alterations to a painting be reversed towards an approximation of the original intent of the painter? How much reversal of alterations is, in fact, desirable in present-day contexts?

Clearly a conservator cannot and must not decide these issues alone. Curatorial and art-historical considerations are often paramount in identifying courses of action. But it is through the conservator's individual perception and skill that those actions must be carried out, and conservation – like politics – is the art of the possible. In practice this means that every treatment evolves empirically from an assessment of present condition, through a discussion of possible alternatives to a unique proposal for treatment which may itself change direction as work proceeds. It may be a truism to say that every painting is different and determines its own treatment, but human skill and judgement alone can decide how and how far to follow a particular course. A particularly refined sensibility is often necessary to know when to stop or when to do nothing at all.

These twelve paintings all had combinations of different problems, assessed and treated with admirable skill and sensitivity by the conservators who worked on them. For perfectly justifiable reasons – as the catalogue explains – different solutions were adopted in different cases for similar problems. The issue of whether or not to retain structural additions or repaints is often a complex one to resolve. Should we return to what is left of the artist's intent? Should we preserve these later episodes in the history of the painting? Should we respect the fluctuations in the history of taste that they represent? If the decision is made to remove them, can it be done safely, without endangering the original? The answers to these questions may be quite diverse – for example, the decisions made for Veronese's S. *Jerome with a Donor*, Rubens's *Venus, Mars and Cupid* and Teniers's *Peasants Conversing* are very different. One of the fascinations of studying this series of conservation treatments is to follow the reasoning behind the actions of conservators, advised by curatorial and art-historical colleagues.

The investigation of original materials and techniques brings in another advisor to the conservator, the conservation scientist. When paintings are being cleaned or treated structurally, the conservation scientist can often study the components of a picture that are not normally accessible, secure in the knowledge that materials are reliably authentic. Minute samples can be taken from the backs or edges of paintings or from the margins of old damages for support and pigment analysis, and from surfaces uncontaminated by later varnishes and retouching for medium identification.

Some of the pictures in this group (principally those by Cuyp) were chosen for treatment because they share a problem long identified in many collections throughout the world but hitherto little understood – the blanching or whitening of certain areas of paint. It is now clear from studies here and elsewhere that we are dealing with a complex combination of surface deterioration and pigment change that may or may not be superficially reversible; if not, an aesthetic decision must be made as to whether the blanching should be lessened by retouching or left to stand as a visible signifier of material change.

All the paintings in this group were cleaned. The often dramatic effects of varnish removal and the freeing of original surfaces from old repaints can allow radical reassessments of the genesis, quality and condition of a particular work. The conservator, who is the instrument of this change, sees cleaning and restoration as only part of the long process of examination and treatment – and yet it is, without doubt, the most revelatory stage. It is difficult to convey the sense of excitement that a conservator feels as cleaning away obscuring layers re-establishes form and colour and gradually allows a painting to work again. There is an extraordinary intimacy inherent in this recreative process that, at best, links the conservator, the painting and the artist's hand in a relationship that spans the centuries. In consequence, it is wise to combine the close and detailed knowledge that the conservator derives from immediate and prolonged contact with the work, with the broader and more detached viewpoint of the curator and art-historian, in arriving at an overall assessment of the cleaned painting.

Although curators are usually art-historians, the priorities of the two in reviewing the necessities and results of conservation may not be the same. The curator must think first of the collection and the implications of conservation processes for exhibition and display, framing, lighting and so on – and only then of the information they provide for didactic presentations and catalogues. Questions raised about changes to original format, for example, exercise curators greatly, since historic hangs and period picture frames could be compromised by further alteration.

The art historian's view may be a different one. A cleaned picture is seen in the context of an artist's œuvre, an original commission, a historical

period or culture, a different political or social setting. An art historian is obviously interested in the final results of conservation and cleaning for the visual and analytical information that they convey, but may be equally interested in what the conservator has undone, for clues to the changing history of taste.

It must not be thought that the work or perceptions of conservator, curator/art historian and even conservation scientist are mutually exclusive: they can and do frequently overlap – and there are, indeed, conservator/art historians capable of performing their own scientific analyses. What is vital to all of them is that the period of a conservation treatment is fully utilised to study a painting from every angle, to record every clue to its origin and history. It may not be removed from its frame again for another century and so essential information should not be missed. Some of the clues discovered during the study of these twelve paintings are described in the catalogue below. To mention just two examples: the complex fragmentation of Veronese's Lendinara altarpiece in the late-eighteenth century has resulted in the puzzling image of the Dulwich canvas, with its disappearing and reappearing lion and remains of S. Michael; and the X-ray of Rubens's *Venus, Mars and Cupid* reveals *pentimenti* and the fascinating technical detail of cusping along an internal seam, giving rise to interesting speculations about the re-stretching of canvases in Rubens's workshop.

So far, we have only considered the views of professionals closely connected with museums themselves. But what of critical and uncritical observers from outside the museum world? Whether cleaned paintings appeal to a particular viewer or not is a matter of personal taste. It is fairly simple to explain why gallery-goers should like restored paintings: increased clarity, the removal of confusing obfuscation, a feeling that we are closer to the artist's intent – all these sensations are easily conveyed to the viewer. They are, after all, the basis of why we clean paintings in the first place.

But we cannot ignore the regular criticism levelled at the whole notion of the conservation and restoration of paintings, particularly cleaning. This is an argument that has smouldered and caught fire at various moments since it erupted with particular ferocity in mid-nineteenth century London and brought the National Gallery's first Director before a Parliamentary Select Committee. It is an argument that has been debated at length elsewhere and I do not intend to dwell on it here. However it is worth mentioning one root of it which critics clearly sense, but seldom spell out – and that is what is seen as a profound unease about the ambivalent nature of conservation itself.

Conservation stands at the junction of history,

the arts and the sciences, and there is understandable confusion as to whether it is an art, a craft or an exact science. It is, in fact, a combination of all three and more besides – but at various points in its history it has been claimed for both metaphysics and positivism and used to demonstrate philosophies and certainties that it could not possibly sustain. Conservation is empirical, but it is an empiricism in the service of the most sublime material creations of our cultural past. There is an admitted incongruity about the matter-of-fact terminology of the conservator when applied to objects of almost mythical status. It may be partly this that arouses such hostility when cleaning controversies spring up. The inference is drawn that conservators are interested only in physical and chemical structures, are mere technicians incapable of aesthetic or historical judgement – but these views miss the point and, as a colleague wrote recently, provide 'no more than a routine patrol of the boundaries of the two cultures.'

Conservation is, above all, cross-cultural and multidisciplinary. Conservators have to bring a range of knowledge, skills and sensibilities to their work that informs every examination and treatment they carry out. Only by explaining choices, decisions and actions in context as they do in a catalogue such as this will conservators demonstrate why the paintings that belong to all of us are safe in their hands. And explain they must, since much of the most important work they do is unseen and unappreciated by the casual viewer. Max Friedlaender wrote in *On Art and Connoisseurship*, 'the business of the restorer is the most thankless one imaginable....his accomplishment remains out of sight, his deficiency leaps to the eye...'. A pessimistic view, written at a gloomy moment in history – and, in any case, not true. The work of the conservator is challenging and the responsibility is great, but the results, as we see, are rewarding indeed.

Finally it is a pleasure to mention the role of one more vital participant in the work seen here – the sponsor. Sponsorship itself has been singled out for adverse comment in recent years by critics who express doubts about sponsor-led restoration projects, claiming that they are sometimes unnecessary. Not so here. The twelve Dulwich paintings were all in need of conservation to guarantee their future stability and enlightened patronage allowed it to happen. Enlightenment in this case means a responsible sense of caution, taking soundings among a range of professional colleagues uninvolved with the project under consideration. Only when the advisability of the treatments was generally agreed did the sponsor agree. Thanks are due to them. The perceptions of all of us have been enriched by their generosity.

Herbert Lank

Limits of Painting Restoration

Current restoration materials, pigments, media and varnishes ensure that the former need for frequent treatment of paintings is considerably reduced. Bearing in mind that repeated conservation is undesirable, further interference with a painting in a public art gallery with controlled environment should be unnecessary within the next century. This desirable aim is, of course, unlikely to be achieved where the paintings travel out on frequent loans.

It is important that the visitor can be confident that the restoration of the paintings on display is of a desirable minimum and that nothing has been done to obscure the genuine image. It is not the restorer's goal to make a painting look 'as it left the master's studio'. One has only to consider the craquelure pattern and some of the changes caused by exposure to light: increased transparency of paint layers and discolouration of certain pigments, to realise that the changes wrought by the passage of time are part of the message that Old Master paintings convey to us to-day. This is evident, for example, in the paintings by Aelbert Cuyp shown here.

Restoration will need to be confined to areas of actual paint loss, without infringing on well preserved original paint. The need to restore these losses at all is due to the fact that, were they to be left untouched, their irregular shapes would distort the image by drawing attention to their presence. This can be seen on photographs taken after cleaning, before restoration. In some instances old abrasions caused to areas of original paint, which may have removed top glazes or exposed the tops of the canvas weave, can be disturbing and retouching is unavoidable. The Veronese fragment (No.1) posed problems in that all the edges are jagged and that attempts had been made in the late-eighteenth century to obliterate the lion, symbol of S. Jerome.

In order to ensure the required longevity, restoration has to be carried out not only with stable materials but also with rigorous control in the way that they are handled and applied to the losses of paint. Failure to do so means that cleaning will soon have to be repeated, with the attendant risk of weakening the medium of the original paint. These materials need not be identical to those used by the artist. Indeed, the attempt to do so would defeat the purpose. The materials of the painting, especially the medium of the paint, will have changed with age and it will be necessary to mimic these changes in the restoration. The medium, that is the binding material of the pigment, usually drying oil, linseed or walnut, must also differ from that used by the painter, as oil darkens and hardens in time. The distribution of paint particles will be subtly displaced. Formerly, restoration was usually carried out in oil paint, which itself would change over a period of about 40 years and therefore no longer match the tonality of the original, to the detriment of the appearance of the painting. The eventual removal of the discoloured oil retouchings, differing little in solubility from the original paint, becomes a hazardous operation. Furthermore, whenever appropriate, the restorer prefers to make the retouchings both slightly lighter and less complex than the original paint, in order to allow them to be distinguishable on close scrutiny, while at the same time being unobtrusive at a viewing distance.

The build-up of the original paint layers requires careful examination before the restoration is begun. Contrary to received opinion, the Old Masters did not have recipes now lost, or impenetrable secrets, which allowed them to paint with those luminous and subtle effects beyond the reach of the modern painter. Workshop practice evolved very gradually over the years and varied in time and place. The characteristic structure of paintings of differing schools and periods can be determined and defined by analysis: technical, stylistic and scientific. A painting can usually be identified by period and locality. What it is not always possible to do with certainty, in the absence of reliable documentary evidence, is to tell a painting by, say, Rubens from a similar painting carried out in the workshop at the same time.

Very small, pinpoint-sized paint losses can be retouched by a direct match to the original paint. For larger losses it will be necessary to proceed by building up the paint layers stage by stage: priming, ground, dense body paint and glazes. This not only ensures a lasting match but also allows the possibility of leaving specific losses just visible at a lower stage of the paint layers. This could be appropriate in the restoration of a

severely damaged painting. To restore such a partially preserved painting to the full extent would tip the balance towards an unwarranted amount of new, as against original, paint. One has only to think of an old ruin 'rebuilt as it used to be' to be wary of such a solution. In those circumstances the gallery visitor would be liable to lose confidence in the authenticity of the paintings on view.

Decisions on the extent and nature of the restoration are reached in discussions between restorer and curator. A fifteenth-century Italian panel requires a different approach from a seventeenth-century Dutch flowerpiece. The decisions can also be affected by the location and the kind of rooms in which the paintings are displayed. A museum such as Dulwich Picture Gallery, top-lit in daylight, may require a slightly more matt final varnish on the paintings to reduce the effect of glare and reflections than a gallery largely lit by low level daylight with additional artificial lighting.

For paintings on public display, the task is for all restoration of paintings to be kept within set limits. It must never be allowed to come between the work of art and the visitor.

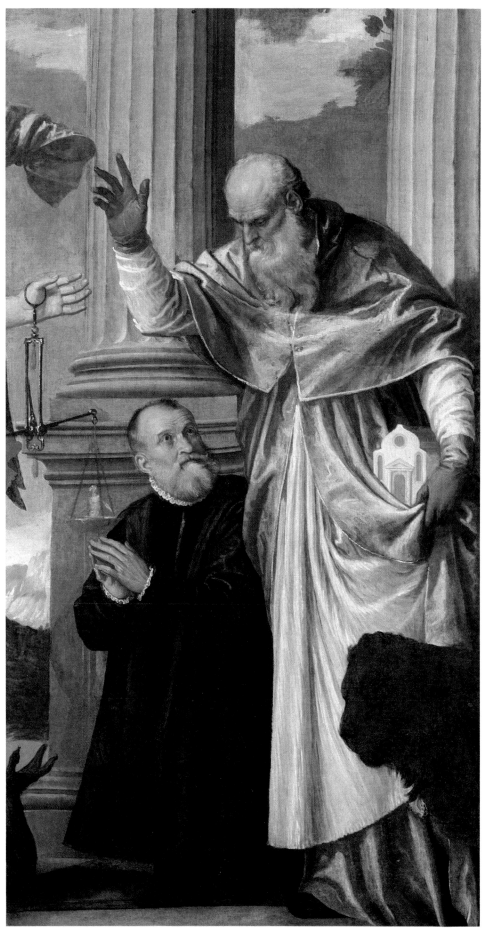

Veronese, *Saint Jerome and a Donor*, after conservation.

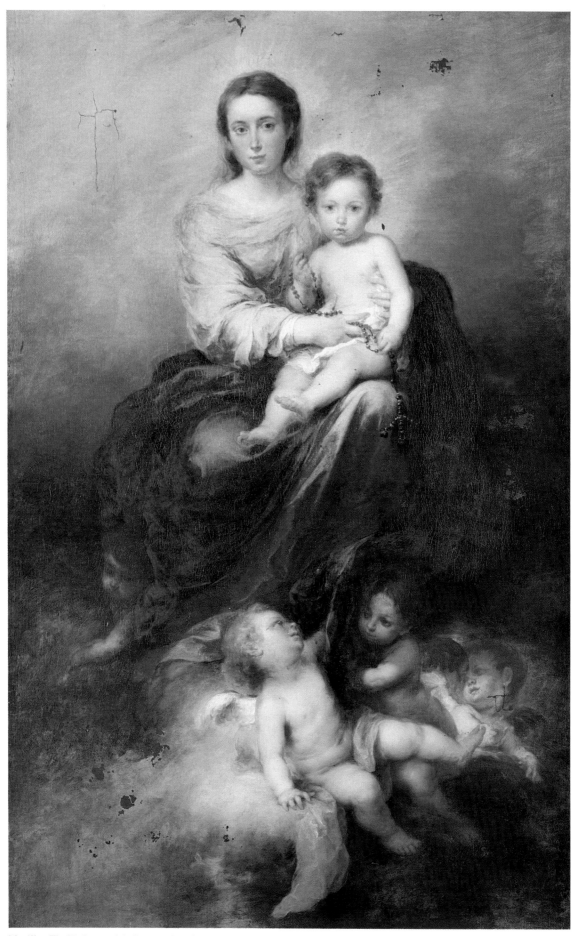

Murillo, *The Madonna of the Rosary*, after cleaning, before restoration.

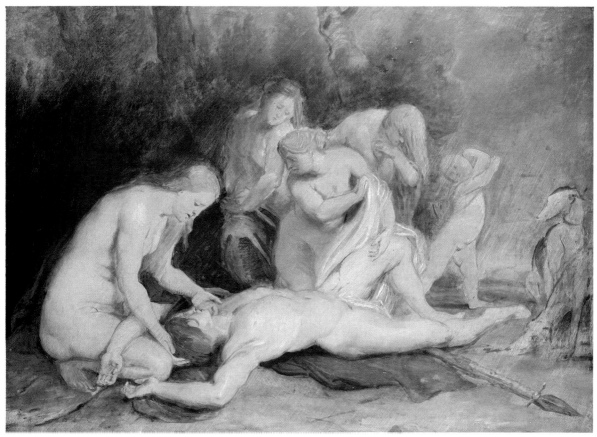

Rubens, *Venus mourning Adonis*, after conservation.

Teniers, *Peasants Conversing*, after conservation.

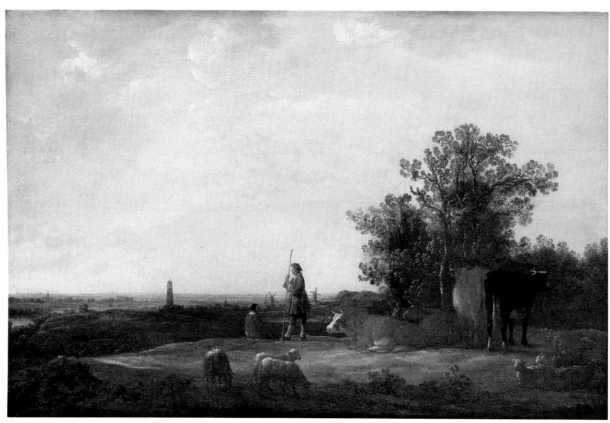

Cuyp, *View on a Plain*, after conservation.

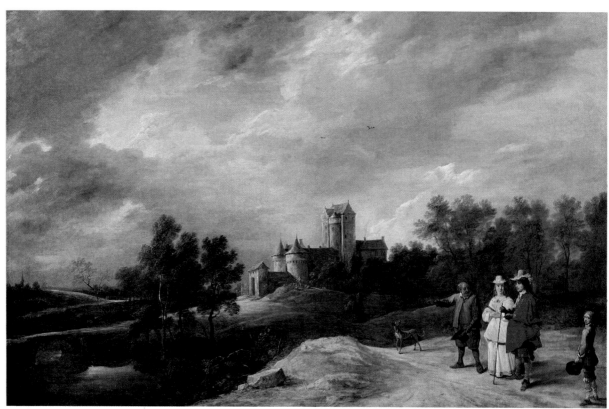

Teniers, *A Castle and its Proprietors*, after conservation.

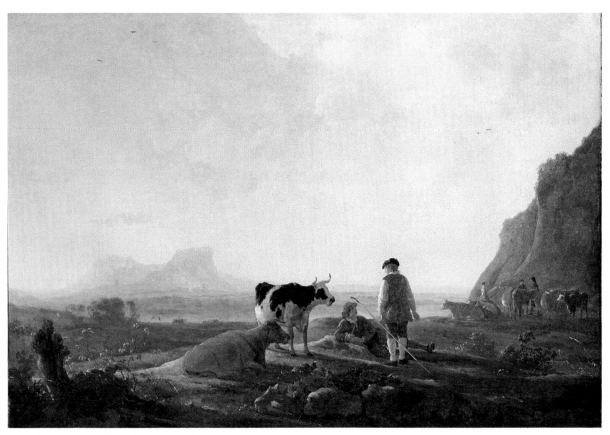

Cuyp, *Herdsmen with Cows*, after conservation.

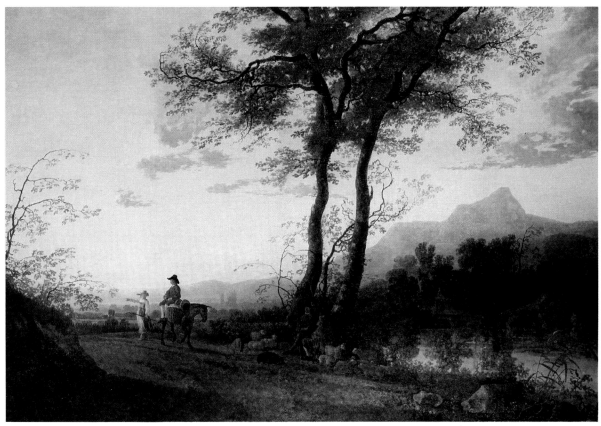

Cuyp, *A Road near a River*, after conservation.

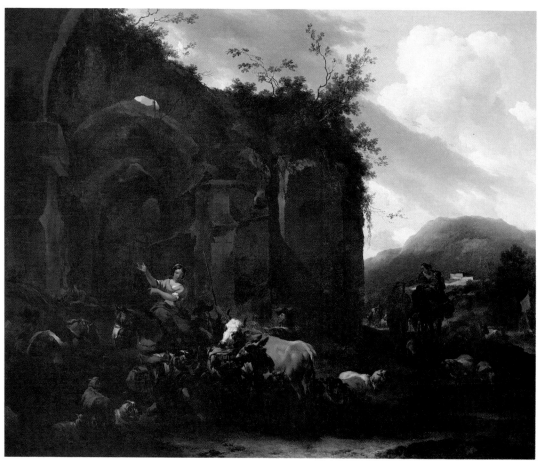

Berchem, *A Farrier and Peasants near Roman Ruins,* after conservation.

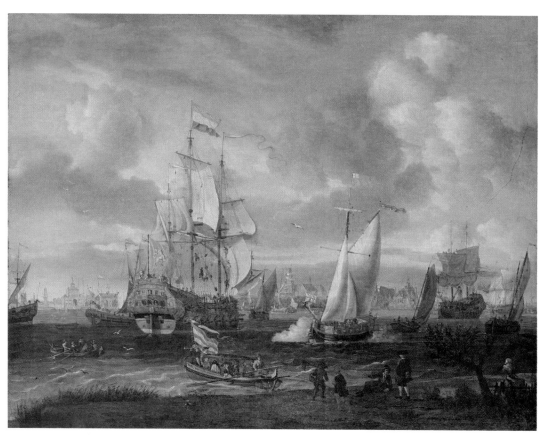

Storck, *An English Yacht saluting a Dutch Man-of-War in the Port of Rotterdam,* after conservation.

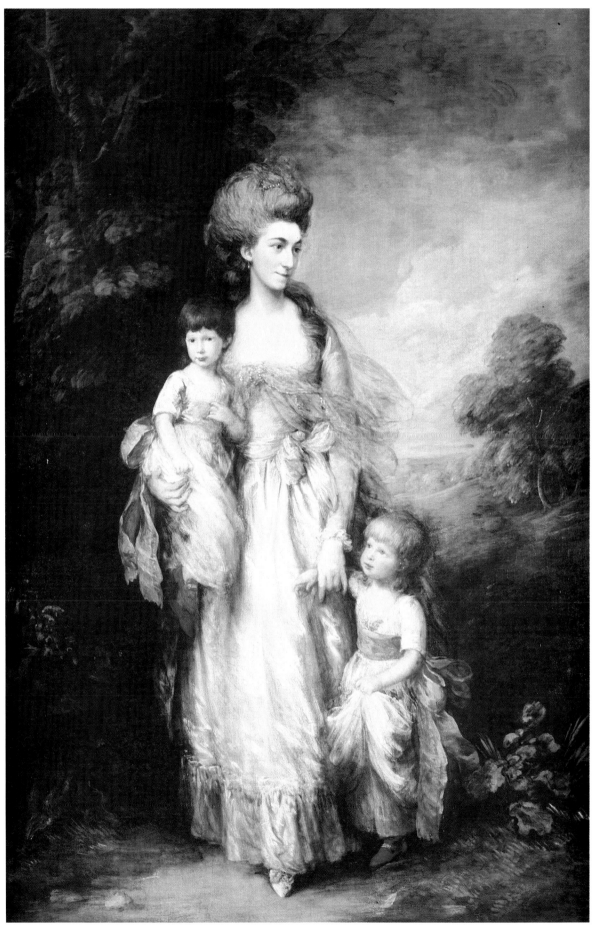

Gainsborough, *Mrs Elizabeth Moody and her two Sons,* after conservation.

A Veronese, *Saint Jerome and a Donor*, macrophotograph showing abraded dark-blue upper layer in the sky.

B Veronese, *Saint Jerome and a Donor*, cross-section from a dark-blue area of sky. Over the discoloured brownish-yellow gesso ground there are two blue paint layers, both containing azurite and lead white. The larger particles of azurite in the upper darker blue layer have an intense colour, and are mixed with a small amount of lead white. Photographed at a magnification of 750X.

C Veronese, *Saint Jerome and a Donor*, cross-section of a sample from the mid-tone of S. Jerome's red outer robe, showing several pinkish-red layers. The paint consists of lead white, red lake and small amounts of vermilion and black. A thin and rather pale red lake glaze is visible at the top of the cross-section. Photographed at a magnification of 480X.

D Veronese, *Saint Jerome and a Donor*, cross-section through a brown shadow of S. Michael's green drapery. The light blue sky paint (azurite and white) runs beneath S. Michael's drapery at the point from which the sample was taken. The green paint contains large particles of malachite mixed with yellow earth. There is a fragmentary brown layer at the surface which consists of yellow earth with a little red earth and black. Photographed at a magnification of 450X.

E Murillo, *The Madonna of the Rosary*, dispersion of discoloured smalt particles

F Cuyp, *View on a Plain*, cross-section of a sample from the blanched yellow-green area bottom right. There are two yellow-green layers. EDX analysis identified the pigments as yellow earth and yellow lake, together with a small amount of lead-tin yellow and bone black. The yellowish-white appearance in the upper part of the top paint layer is due to fading of the yellow lake. It contains chalk as an ingredient in the substrate, as was common in the seventeenth century, and yellow lakes prepared in this way are particularly fugitive (cf. G). Photographed at a magnification of 750X.

G Cuyp, *View on a Plain*, cross-section of a sample from an unblanched yellow-green area at the bottom of the right edge which has been under the frame rebate. The sample is from an area immediately adjacent to F so the pigments and layer structure are the same. However, the top layer does not appear yellowish-white at the surface; the paint has been protected from light by the frame rebate and the yellow lake has not faded. Photographed at a magnification of 540X.

H Cuyp, *Herdsmen with Cows*, cross-section of a sample from a blanched brown area in the foreground. Over the light orange-brown ground is a yellow-brown layer containing yellow lake, yellow earth, bone black, vermilion and some verdigris (not visible in this photograph). The dye-stuff in the yellow lake has faded leaving colourless particles of the chalk-containing substrate which are visible at the top of the cross-section. The roughness of the surface may also contribute to the blanched appearance of the paint. Photographed at a magnification of 600X.

The Catalogue

Besides those individually signed, the introductory texts have been written by Richard Beresford (Nos.1, 10, 11) and Giles Waterfield (Nos.4, 5). The glossary was compiled by Lucy Till. The conservation reports on Nos.2 and 6 are the work of Ian McClure with the collaboration respectively of Claire Chorley and Pippa Balch and are partly based on analytical reports by Narayan Khandekar and Nicola Pause. The other conservation reports are assembled from the examination, analytical, and treatment reports of the scientists and conservators concerned. These were Simon Bobak (Nos.1, 8), Catherine Hassall (Nos.7,10), Patrick Lindsay (No.9), Sophia Plender (Nos.3,4,5,7,11), Anthony Reeve (Nos.4,9), Nicole Ryder (No.10), Anna Sandén (No.1), Marika Spring (Nos. 1,4,5,7,8), and Nonie Tasker (Nos.8,12). We are extremely grateful to all of them for their contributions and for their patience in dealing with endless editorial queries.

The materials mentioned in the treatment reports, and in particular the solvents, are safe in the hands of a trained conservator, but may cause damage if used inexpertly.

1 Paolo Veronese (probably 1528–1588)

Saint Jerome and a Donor

Canvas, relined, 224.5 × 120 cm, excluding a strip 3 cm wide at the bottom edge which is part of an addition now folded round the stretcher.

DPG no.270

Bourgeois Bequest, 1811

A donor, identifiable as Girolamo Petrobelli (died 2 May 1587), turns to his protector S. Jerome, who is dressed as a Cardinal and accompanied by his traditional symbol of a lion. The saint holds a church which refers to his role as one of the four Fathers of the church.

The canvas is a fragment from a major altar-piece. This is clear in the first place from the dismembered hand at the left edge holding a balance and the fluttering drapery above, which must originally have belonged to a figure of S. Michael trampling the Devil. The Devil's forearm and talons are visible at the bottom. These details were painted out when the altar-piece was cut up in the eighteenth century, but were brought to light when the picture was cleaned by Hell in 1948–53. At the same time the lion in the bottom right corner was revealed; it had previously been overpainted with a continuation of the Saint's robes.

The fragment comes from the bottom right corner of the altar-piece, which must originally have been some fifteen feet in height. Two other fragments are known. The bottom left corner, showing another donor – Antonio Petrobelli – with S. Anthony Abbot, is in the National Gallery of Scotland, Edinburgh. In the National Gallery of Canada, Ottawa, is most of the upper half showing the *Dead Christ supported by Angels*. Both the Dulwich and Edinburgh fragments contain parts of the central figure of S. Michael, but the central portion of canvas is lost (see reconstruction, Fig.1).

Something is now known of the early history of this altar-piece which in 1795 was described by Pietro Brandolesi as having recently been removed from the Petrobelli chapel in the church of San Francesco at Lendinara, near Rovigo.[1] The altar-piece is also described in two earlier manuscript sources: a history of Lendinara by G. Silvestri of 1755 and an index of works of art to be seen in the town made by G. Masatto at an unknown date before 1783.[2] It also appears in an inventory of the church drawn up on 30 August 1769, which describes:

> Next to the pulpit: an altar of 'pietra dolce' [literally soft stone] with an altar-piece said to be painted by Paolo Veronese representing S.

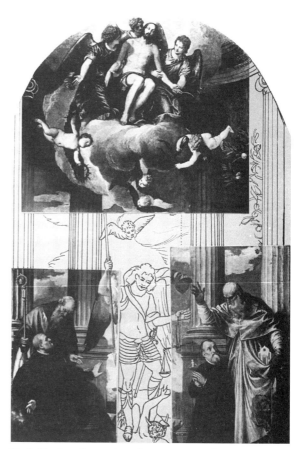

Fig.1 The Lendinara altar-piece: reconstruction.

Michael Archangel, S. Jerome, S. Anthony Abbot ([the chapel] under the patronage of the Petrobelli family of Lendinara) with a painted marble altar-frontal [?] representing all the instruments of the Passion of Our Lord Jesus Christ ...'.[3]

The church of San Francesco belonged to the Franciscan convent of the Minor Conventual Friars. Following the suppression of the order in 1769, the contents were dispersed and the church sold. By 1785 both church and convent had been completely destroyed. Between 1769 and 1795 the altar-piece was cut in pieces, presumably to make it more saleable. The Edinburgh and Ottawa fragments passed into the collection of the Duke of Sutherland at Stafford House. The Dulwich fragment was in the possession of Noel Desenfans by 28 February 1795, when it was put up for sale with Skinner and Dyke, London, described as a 'Cardinal blessing the Founder of Lorretto'.

The church of San Francesco had been one of the oldest and most magnificent in Lendinara. On the main altar was another altar-piece by Veronese of the *Virgin and Child in Glory with Saints*, commissioned by Francesco Gherardini c.1555, and now in Narbonne. The eight funerary chapels which belonged to various noble families of the town were finely decorated, though none perhaps more grandiosely than that of the Petrobelli.

The chapel was dedicated to S. Michael, whose figure would originally have dominated Veronese's altar-piece. The erection of the stone altar in 1563 was commemorated in an inscription which identified the patrons as Antonio and Girolamo Petrobelli who were thus represented, as is to be expected, with their name saints. The canvas was presumably painted at the same time.

The altar-piece was crowned by a vision of the dead body of Christ and it is to this that the gloved hand of Jerome calls the attention both of Petrobelli and the spectator. While the donor seems to have been piously considering the fate of his own soul in S. Michael's scales, his protector Saint indicates his Saviour, whose sufferings on behalf of mankind were further recalled by the instruments of the Passion which decorated the altar front. In spite of the mutilation of the altar-piece, the fragments retain much of their power. Following its restoration, and understood in its original context, the Dulwich canvas emerges as a majestic statement of the hope of Salvation.

1 As first noted by G. von Hadeln, *Paolo Veronese*, Florence, 1978, pp.130–1, 161–2.

2 See Paola Pizzamano, in P. L. Bagatin, P. Pizzamano and B. Rigobello, *Lendinara, Notizie e Immagini per una Storia dei Beni artistici e librari*, Treviso, 1992, pp.212–13.

3 'Contiguo al pulpito: Un altare di pietra dolce con palla, che dicesi dipinta da Paolo Veronese, esprimente S. Michiele arcangelo. S. Gerolamo, S. Antonio Abbate (di giuspatronato della Casa Petrobelli di Lendinara) con antipetto di marmorina dipinto esprimente gl'istrumenti tutti della Passione di N.S.G.C.', quoted in A. Sartori, *Archivio Sartori*, Padua, 1986, II, 1, p.910.

CONSERVATION REPORT

Previous recorded treatment

The picture was treated by Holder in 1911 and by Hell in 1948–53. On the latter occasion repaint was removed from the left edge which previously covered S. Michael's drapery, hand and scales and the Devil's arm, and from the bottom right corner where an extension of the Saint's robes had been painted over the lion (Fig.2). It was then revealed that the lion had been largely scraped off, but it was decided at that time not to attempt to reconstruct the area.

Examination and analysis

The canvas is a fragment (see above) and had been glue relined. The fragment had been extended at the bottom by the addition of a canvas strip 8–9 cm wide and at the right edge by filling applied direct to the lining canvas to a width of 5 cm. The left and top tacking edges, before the present relining, were part of the original painting and these have now been unfolded. There is also an original seam 12 cm from the left-hand side. On the right-hand side where the filling stops, there is evidence of tack holes in the original canvas indicating a previous smaller stretcher size.

Repairs have been made with canvas insets in the lower left and right corners and there is a small horizontal tear lower left. The canvas and lining were slack on the stretcher and the inset in the lower left corner was lifting. The fillings along the right edge were uneven and unsightly.

During treatment a number of paint samples were taken for analysis. These showed a gesso (calcium sulphate) ground.

The sky has dark blue patches and samples were taken to establish whether or not these were original. The samples showed a two-layer structure, the lower layer with finely ground pale azurite (which has a greenish-blue appearance) and the upper with coarse azurite of an intense blue (see p.24, A,B). In spite of the patchy appearance which it gives, this upper layer is certainly original.

A paint sample taken from S. Jerome's outer red robe showed several layers containing red lake and lead white with small amounts of black and vermilion. Glaze-like paint consisting principally of red lake was used to indicate the dark red shadows of the robe (see p.24, C).

S. Jerome's inner robe has a more purple colour; the paint contains some blue pigment in addition to red lake, white and vermilion. Azurite is the blue used in the underlayers; the more expensive pigment ultramarine is reserved for the final glazes in the shadows where it is mixed with red lake.

The green drapery at the left edge of the composition from S. Michael's cut-off drapery contains a mixture of natural malachite and yellow earth with the addition of black in the shadows (see p.24, D).

Before treatment the varnish was moderately discoloured.

Treatment

After examination it was decided, in view of the failure of old repairs and the unreconstructed state of the lion to treat the canvas again.

The discoloured varnish and those discoloured retouchings which were easily soluble were removed with a mixture of industrial methylated spirit and white spirit in the proportion 1:5. Older retouchings were softened with a 1:2 mixture and subsequently removed with the aid of a scalpel. Some repaint in the remnants of the lion and in the lower right corner of the red robe could not

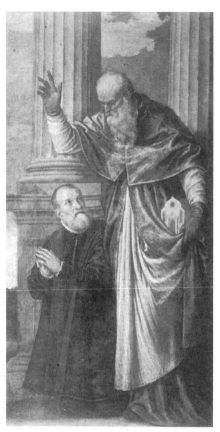

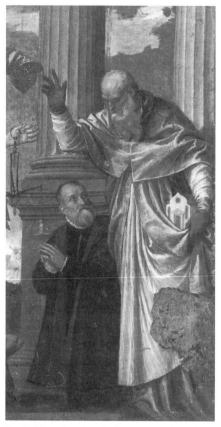

Fig.2 Before cleaning of 1948–53.

Fig.3 After cleaning, before restoration, showing the unreconstructed state in which the lion had been left after treatment in 1948–53.

be removed without risk to the original paint and was left.

The painting was faced and the old lining canvas, which adhered poorly to the original, was removed. The 5 cm strip of filling at the right edge was also removed. The original canvas turned over at the top and left edges was unfolded and flattened. The lining glue was removed by dry scraping and the tears and damages repaired with rabbit-skin glue before composite glue lining onto Irish linen canvas. The addition at the bottom was too large to be hidden by adapting the frame and was folded back to hide it whilst keeping it as an historical record.

The strips of original canvas unfolded at the top and left edges retain remnants of original paint under dark grey-brown repaint. However the original paint is severely damaged by numerous tack holes and it was decided not to attempt to restore these areas. They are currently hidden by the frame.

After removal of discoloured varnish layers and darkened retouchings an isolating layer of MS2A varnish was brushed on (Fig.3). The losses were filled with a chalk and gelatin putty containing a small amount of stand oil. In some areas where the flatness of the putty fillings disturbed the surface texture, a texture was built up with a filler of chalk and polyvinyl alcohol. This layer was isolated with shellac. Retouching was carried out in egg tempera with dry pigments and MS2A glazes.

At some point in the past when the altar-piece was dismembered, the lion in the right foreground had been scraped off and the majority of the original paint layers removed. S. Jerome's red robe and white surplice were then extended to cover the remnants of the lion. In 1948–53, when the painting was cleaned, most of this repaint was removed, leaving only some of the less soluble repaint and a considerably damaged lion, with the ochre-coloured lower paint layer as the predominant feature. However, some isolated areas of original brown and black paint layers remained. Original black paint from the lion's left eye could also be seen. The painting had been displayed in this state for the last 45 years.

In considering the restoration, it was felt that, when viewing the painting, attention was drawn excessively to this damaged area at the expense of a full appreciation of the image. Two options were considered: one to reconstruct the lion to a reasonable approximation of its original state; the other to reduce the tonality, in order to bring it closer to the rest of the painting and to the scattered remains of original paint in this area. It was decided that the latter option would be the least intrusive. By strengthening the features of the original eye and nose, the face of the lion was indicated without being totally reconstructed. Thus some feeling of the three-dimensional effect was re-established without intervening to an excessive degree with what survives of Veronese's original.

28

2 Sir Peter Paul Rubens (1577–1640)

Venus, Mars and Cupid

Canvas, relined, 195.2 × 133 cm

DPG no.285

Bourgeois Bequest, 1811

Fig.4 Rubens, Detail of Minerva from '*Peace and War*', canvas, 203.5 × 298 cm. National Gallery, London (no.46), reproduced by permission of the Trustees of the National Gallery.

This mythology, of virtually life-size figures, has always ranked as the finest autograph painting by Rubens in the Dulwich Picture Gallery, which with the Bourgeois Bequest of 1811 had received such a wealth of oil sketches from various phases of Rubens's activity (see No.3 below), as well as *Hagar in the Wilderness* and the *Portrait of Catherine Manners, Duchess of Buckingham*. After its recently completed treatment at the Hamilton Kerr Institute the *Venus, Mars and Cupid* is to be seen in its full glory as one of the prime treasures of the collection.

Since Peter Murray's catalogue, published in 1980, this masterpiece by Rubens of the mid-1630s has been accepted as having begun its documented history when seen in 1720 by Watteau in the collection of the Duc d'Orléans. Murray quotes Dubois de Saint Celais's *Description des Tableaux du Palais Royal* of 1727 and Thiéry's *Guide des Amateurs ...à Paris* of 1787 which both describe the picture in the Palais Royal before the Orléans sale of April 1793. Since the publication by Alexander Vergara of the inventory of Juan Gaspar de Cabrera (1625–1691), 10th Admiral of Castille, we can with confidence add a further element to the earlier provenance of the picture.[1] The inventory describes the Rubens Room (*Pieza de Rubens*):

> It has the following paintings, with their black frames and gilded mouldings ...
> 82. another painting on canvas two and one third varas in height and in width one and one-half [varas] and three dedos in which one sees a naked Venus sitting, covered with a blue cloak over her waist and her right hand over one breast from which jets of milk spurt, which a small Cupid catches in his mouth, and by her feet there are a [quiver?] and a bow and a shield and on one side is Mars armed and with his head uncovered.

The historical evidence on the manner of framing in black and gold is clear. The description of the subject is unmistakable. The canvas, described in varas and dedos, measured approximately 196 × 128 cm. Indeed it may have been inherited by the 10th Admiral since his father, the 9th Admiral had owned a *Venus, Mars and Cupid* which may well have been acquired during Rubens's lifetime.[2]

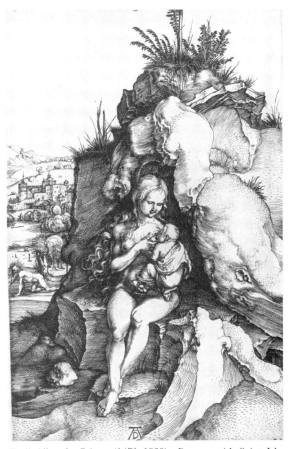

Fig.5 Albrecht Dürer (1471–1528), *Penance with Saint John Chrysostom* (B.63), engraving. Photograph, The Warburg Institute.

29

The recent cleaning has restored to the proper values the opulent contrasts of the soft surfaces of hair and rich stuffs, velvet, bullion and silk, with the hard reflective surfaces of plate armour and accoutrements and the columnar architecture in half shadow; and supremely of the nacreous tints of Venus and Cupid with the golden brown skin, fiery and proper to Mars on his refulgent throne, and his infant acolyte glowing as he seems to be tugging aside the vermilion curtain, that swathe of rich red which sets off the vibrant flushes of Venus and Cupid. In this erotic theme Rubens anticipated his painting of *The Origin of the Milky Way* (Prado, Madrid) designed with full baroque dynamism for the decoration commissioned in 1636/8 for Philip IV's hunting-lodge outside Madrid, the Torre de la Parada. Formally the posture and action of Venus most closely reflect those of Minerva in *'Peace and War'* (National Gallery, London) that abundant painted emblem given by Rubens to Charles I in 1629/30 to commemorate his London embassy (Fig.4). Both pictures show the influence of Titian which had so affected Rubens during his second diplomatic stay in Madrid in 1628, with its opportunities to encounter, study and copy paintings in the superlative Habsburg collections assembled in Spain by Charles V and Philip II. The X-radiograph of the Dulwich picture magnificently shows the technique learned from Titian (Fig.7).

The pungency of Rubens's Venetian *cromatismo* is strongly sensed after his return to Madrid. Yet throughout the last decade of his painting career in Antwerp Rubens's style was overlaid with the longer and more deeply felt influence of his roots in his artistic training in northern Europe. He never entirely fulfilled Berenson's often quoted words, *'Rubens è un italiano'*. Dürer's *Penance with S.*

John Chrysostom, an engraving of before 1495 (Fig.5), was almost certainly in Rubens's recollection and imagination when he created the Dulwich Venus. The King's daughter, seated in the rocky cave of Dürer's wilderness, suckling her infant, with her legs crossed at the ankles and her right arm offering her left breast, suggests a prototype for Rubens's Venus. This is not an isolated case of Rubens turning to a Dürer engraving in the search for an apposite image. As late as the penultimate year of his life, Rubens patently used Dürer's *The Promenade*, another engraving of c.1495, for the composition of his marvellous group portrait, *Self-Portrait walking with Hélène Fourment and their infant Peter Paul in leading strings* (Metropolitan Museum of Art, New York).

Signs of Rubens's creativity in the Dulwich picture are evident in the *pentimenti* which were revealed by X-radiography: the right leg of Cupid above the knee was originally bare, his left leg was angled down from Venus's thigh clear of her drapery; and Venus's left leg was originally tucked behind the shield from below the knee

In bringing so vividly to life in painting the story of the adultery of Venus, wife of Vulcan, with Mars and her resulting love-child Cupid, Rubens created an indissoluble amalgam of two of his greatest predecessors either side of the Alps, Dürer and Titian.

Michael Jaffé

1 Alexander Vergara, 'The "Room of Rubens" in the collection of the 10th Admiral of Castile', *Apollo*, CXL, 1995, pp.34–9.
2 Vergara, *op. cit.*, p.35, citing C. Fernández Duro, *El Ultimo Almirante de Castilla, Don Juan Tomás Enríquez de Cabrera*, Madrid, 1903, especially pp.103ff.

CONSERVATION REPORT

Previous recorded treatment

Holder reported on the condition of the painting in 1911 and recommended lining, but there is no record of whether the treatment was carried out. The picture was again treated by Hell in 1970.

Examination

When examined in 1992, the painting was found to require both cleaning and structural work. The painting had received attention at various times in the past and was lined with a glue-paste lining. The four window, mortise and tenon construction

of the stretcher suggested that the last lining was probably carried out in the nineteenth century. At the time of this lining, the painting had been increased in width by approximately 5 cm on both the right and left side, by flattening the tacking margins of the original canvas and extending them with filling to the tacking edges of the new lining canvas. This relined painting now fitted the frame made for it when it entered the collection early in the nineteenth century, suggesting that the lining might be from that date.

The original canvas is made of two pieces, the

horizontal seam running through Venus's legs 43.5 cm from the bottom edge. At some time in the past the hem of the seam has been cut away to reduce distortion on the surface of the painting when a lining canvas was applied. During this or a former lining (paintings on canvas being lined approximately every one hundred years) the weakened joint parted and a gap of about 4 mm has opened up in the centre, which has subsequently been filled and retouched.

There are also several tears in the background and in the thigh of Venus which are possibly cuts made by a liner in the past, trying to remove buckles and air bubbles in the canvas caused by moisture and heat during the lining process.

The paint layer seemed to be in reasonably good condition, although the craquelure was sufficiently raised to be visually disturbing. Although the paint surface was obscured by layers of discoloured varnish which had also blanched, it was possible to see that areas of the painting had faded, such as the purple drapery on the couch, and particularly the blue drapery over Venus's lap, which had the characteristic greyish-green appearance of discoloured smalt (see pp.43–4).

The varnish layer was very discoloured, rendering flesh tones almost orange. There also appeared to be areas of blanching where the varnish had become grey and opaque. This was also apparent on the *Madonna of the Rosary* by Murillo (No.6) and might be the effect of exposing paintings for long periods to high light levels. Paintings at Dulwich have been shown in gallery conditions much longer than most other public collections in Britain.

Treatment

The painting was cleaned using a mixture of industrial methylated spirit and white spirit in the proportion 1:4. In some areas, overpaint was removed using an ethanol/water gel. This was particularly effective in the areas where putty had been liberally applied and overpainted, especially in the additions to the vertical edges. The removal of the filling revealed the original tacking edges and the mark of the fold-over edge which gave the original dimensions. It was decided to return the painting to its original dimensions and reduce the frame to fit.

Removal of old putties from areas of the red cloth on the couch uncovered unfaded red lake where the filling of a minor damage had spread onto undamaged paint, subsequently protecting it from light. Areas of blue drapery had been over-cleaned in the past in a vain attempt to remove the greyish appearance and recover the blue; to the left of Venus the folded end of the cloth had almost been cleaned away.

Removal of varnish from the figure of Venus revealed some wear from abrasion in her head and neck while her torso had several remnants of older layers of varnish. Their removal uncovered an almost undamaged surface with thin oil glazes giving the flesh an opalescent sheen. It is possible that for reasons of propriety Venus's body was left uncleaned when a slightly abrasive cleaning method was used.

After cleaning (Fig.6) it was possible to see that on both sides of the painting there were two lines of tack holes running vertically some distance into the painting. These were consistent with the painting either being reduced in size (folded onto a smaller stretcher) or perhaps fixed into panelling. It is very fortunate and unusual that when the painting was reduced in size in this way, the excess canvas was not trimmed away.

The painting was then given a temporary varnish layer of Arkon P90 and prepared for relining. The painting was faced using two layers of eltolene tissue and CMC (carboxymethyl cellulose).

The lining canvas and glue were then removed. The lining canvas was very degraded and removable only in small sections at a time. The lining glue (glue-paste including a resinous component) was extremely thick and tenacious and was softened using poultices of Laponite RD, and removed with a scalpel. It was possible to see cusping of the original canvas along the seam, indicating that the canvas had been stretched for painting before the lower piece of canvas was added. The ground of the lower canvas is thicker and has a gritty texture. Smears of this ground layer appear on the upper canvas (on the left side) which suggests it might have been added in Rubens's studio during painting. However, the X-ray (Fig.7) does not indicate that the composition was squeezed initially into the upper canvas. Rubens regularly used canvases and panels that were increased in size by stages.

The painting was then tensioned on a loom after local damages had been strengthened. The original seam joining the two canvases had been trimmed prior to a previous lining. The seam, which was still joined at the edges, had sagged in the centre, the lower half pulling away from the upper. It was drawn back together using a system of tapes attached to the lower portion of canvas tensioned over a rigid bar attached to the loom, gradually easing the lower half of the painting towards the upper half. A small amount of humidity was introduced to assist this process. The seam was then rejoined using Paraloid B72 threads and reinforced with Vinamul 6825-coated hemp fibres to bridge and strengthen the join. The painting was treated with moisture to remove any buckles before relining onto a fine linen canvas using Beva 371 as an adhesive. One object of the relining was to avoid impregnating the original canvas with adhesive.

The painting was re-stretched on its old stretcher, which was reduced in size to match the original dimensions. It was given a further loose lining of acrylic-primed linen canvas as a barrier to changes in relative humidity.

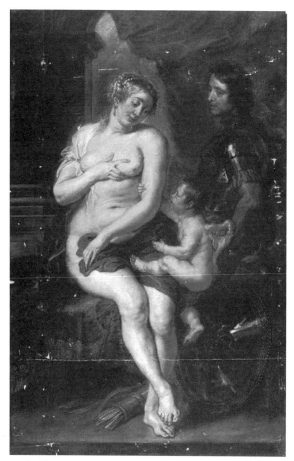

Fig.6 After cleaning, before restoration.

Fig.7 X-ray assembly. Hamilton Kerr Institute, Cambridge.

The painting was varnished with MS2A resin. It was retouched using egg tempera underlayers with MS2A glazes. The losses to the blue drapery were reconstructed and retouches were made slightly blue to recover some of the lost hue of this area.

Before the painting was relined it was X-rayed and this revealed alterations which have been described above (Fig.7). An interesting technical feature can be seen in the drapery covering Venus's true right shoulder and arm, where some impasto drapery has been scraped away during painting. Rubens painted flesh over this area but, although the painting has all the admired features of rapid execution, he did not want the texture of the flesh to be disturbed by the underlying brush-strokes. No change is visible here in the finished painting, showing the thought and planning that went into the composition. The drapery over Venus's lap originally covered her right leg more extensively. In the X-ray, the fabric that Cupid clutches appears very taut. As the blue pigment, smalt, used in the finishing of the modelling has faded, this is no longer apparent. Thick lead white priming is visible at the bottom of the upper half of the painting; and smears of thicker priming appear in various places at the edges.

Damages and paint losses are visible in the X-ray, as are the vertical lines of tack holes at left and right. In general, it can be seen that the painting is freely and boldly executed. Comparatively few changes have been made to the original concept of the painting.

3 Peter Paul Rubens

Venus mourning Adonis

Oak panel, 47 × 66.4 cm, excluding an addition of 1.6 cm at the top edge

DPG no.451

Bourgeois Bequest, 1811

This brilliant example of Rubens's method of sketching in oils on a specially prepared panel, without the more traditional use of preliminary drawings on paper, has recovered the sparkle of creativity in its recent treatment by Sophia Plender. This panel is the best candidate for the 'Sketch by Rubens ... a Dead Adonis' ('*schetse van Rubens ... eenen dooden Adonis*') recorded in the inventory of Jeremias Wildens, a well known collector in Antwerp, taken on 30 December 1653. It is probably also the picture sold in the European Museum Private Sale, London 1792, as lot 306: 'Death of Adonis – Venus and Cupid. Sketch for Madrid' (the significance of Madrid in this context is unclear).

Certainly the Dulwich sketch served for a full-size mythology. This was a magnificent illustration to the closing passage in the Tenth Book of Ovid's *Metamorphoses* (Fig.8). Rubens created a bas-relief of heroic nudes set in a landscape of dense, dark-green foliage, lightened on the right by a view of a rolling, clouded and more wooded distance. In the foreground he set a pair of Adonis's hounds, one licking the blood of his slain master from the ground (indicated in the Dulwich sketch by flecks of scarlet), the other seemingly attentive of his outstretched corpse. Adonis's body sets the firm base for an arch of mourning figures made up by Venus, three nymphs and Cupid, with his quiver, who attend the dead huntsman. Rubens's interpretation of the story shows the highly developed sense of classical form and classical grouping which he had attained by the middle of the second decade of the century.

The full-size original belonged to Thomas Hope, the international banker, who almost certainly acquired it in 1798. It is mentioned in his collection in the manuscript inventory drawn up on 24 May 1813 by John Britton of '*Pictures late the property of Sir Francis Bourgeois R.A.*' which describes in the Middle Room on the second floor of Bourgeois' house in Charlotte Street '*Death of Adonis. Sketch in one colour for large picture in the possession of Thos. Hope Esq. P. Rubens*'.

This sketch on panel was classified in the Dulwich catalogues of 1880 and 1914 as 'School of Rubens'. In 1914 Sir Edward Cook wrote, 'This picture which may be the one described by

Fig.8 Peter Paul Rubens, *Venus mourning Adonis*, canvas, 83.5 × 128.5 cm. Formerly with Duits, London.

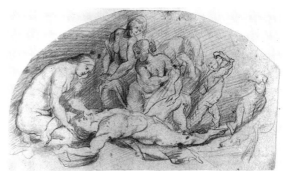

Fig.9 Willem Panneels (c.1600–1632 or later), after Rubens, *Venus mourning Adonis*, black and red chalk reinforced partly with pen and black ink on yellowish paper, 17.2 × 29.0 cm. Print Room, Royal Library, Copenhagen (Rubens Cantoor IV, 38).

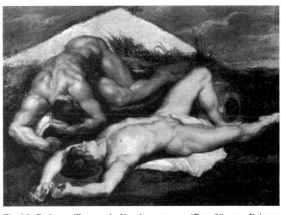

Fig.10 Rubens, *Two nude Youths*, canvas, 47 × 68 cm. Private collection.

Desenfans (No. 92 in his catalogue) was formerly ascribed to Van Dyck; but "the composition is precisely that of the great picture of Rubens, now in Mr Hope's collection" (Mrs Jameson)'. In fact the composition of the preliminary sketch is not 'precisely that of the great picture'. The attitude of the nearer hound was changed considerably; Cupid's quiver becomes horizontal, in sympathy with the stretch of the corpse; the eyes of the right-hand nymph were no longer obscured by the fall of her hair; and, more obviously, the view of open country has been extensively developed. A *ricordo*

of the figure group in the sketch, omitting any suggestion of landscape, has been preserved among the drawings in the *Rubens-cantóor* in the Copenhagen Print-Room. This feeble copy in red chalk, partly reinforced in pen, shows the morphological quirks as a draughtsman of Willem Panneels, the young man left in charge of the carefully guarded material of the Rubens studio during the master's absence on diplomatic business 1628–30. Whoever cut the Copenhagen drawing from some larger sheet of paper had at least some sense of a tympanum group which made the arch of mourners above the corpse of Adonis (Fig.9).

Highly relevant to the invention of the figure of Adonis is a finished study, painted in oil on canvas, c.1612–14, of *Two nude youths* arranged prostrate in different positions (Fig.10). These figures were used by Rubens, with considerable modifications in detail, but in more or less the same relation, in two of the slain at the left lower corner in the Munich *Defeat of Sennacherib* of 1615–17. Rubens had first experimented with the nearer youth, an adaptation in reverse of Michelangelo's *Tityus*, in the Cologne *Death of Argus* of 1611, and later in both the Seilern and Fitzwilliam Museum versions of the *Death of Hippolytus*. He repeated the figure almost literally c.1614 in the Dulwich *Adonis*, and again modified it in 1617, especially in the pose of the arms and in the drapery, to suit yet another context for the *Death of the Consul Decius Mus.*

The peculiar presentation of the figures of the *Two nude youths*, lying on the ground with empty urns, one figure in a sleepy huddle with his head pillowed on one of the urns and his hands across the open neck of it, suggests that Rubens had in mind a mannerist composition: the Fontaine-bleau engraving by Léon Davent after Prima-ticcio's *Jupiter*, a print which he certainly knew. This painting evokes both the restrained passion expressed in *Venus mourning Adonis* and the baroque drama of the *Defeat of Sennacherib*. It also demonstrates the breathtaking vitality which informs even his apparently most motionless figures. In the nymph who turns to gaze on the face of Adonis, Rubens recollected the famous *Crouching Venus* of Doidalses: but, through intent study of a Roman copy in marble, he has in effect recreated her in the warmth of painted flesh and blood. She illustrates to perfection the precepts which he wrote *De Imitatione (Antiquarum) Statuorum.* In the heavy stillness of a moment of grief she seems as capable of motion as the distraught Cupid who divests himself of his quiver with a movement which, although entirely appropriate to the present context, recalls some *putto* in an antique relief, helping his fellows to support a garland.

A lesser master in such an attempt at a renaissance of the antique world might have left us no more than a chilly group of statues immobile in a landscape. The triumph of Rubens in the *Venus mourning Adonis* is so to have interwoven the rhythm of the forms, in themselves so nobly conceived, that nothing can disrupt the unified impact of the whole. He has told the ancient story afresh by giving fresh life to ancient terms. Every glance, every posture, and every gesture reinforces the edifice of lament in a great pictorial masterpiece.

Michael Jaffé

CONSERVATION REPORT

Previous recorded treatment

The picture was 'revived' and revarnished in 1866 and a small addition was then made to the top (see below). It was again revarnished in 1922, 'polished' in 1936 and was treated by Hell in 1953.

Examination

The original oak panel is made up of two horizontal members joined at 24 to 25.8 cm from the bottom edge. There is also an addition at the top which was added in 1866. The original panel is unevenly cut at the top edge and slightly uneven at the right edge. It has a slight convex warp and is roughly bevelled on the back on all four sides. The join has been repaired with three rectangular wooden buttons in the right half of the join as seen from the back. At some stage the join had been re-glued unevenly, resulting in a slight step in the paint surface at the far left.

The panel is prepared with a pale cream ground over which a grey wash has been applied in broad diagonal brush strokes. The top layer of paint does not extend fully to the right edge, but ends in a straight line suggesting that the panel was held in a support when the upper paint layer was applied.

The paint is generally in good condition, but at the top left corner there were several old filled losses with retouchings which extended slightly over the original paint. There was also some blistering in this area which was slightly unstable. There were also a few other small chips and

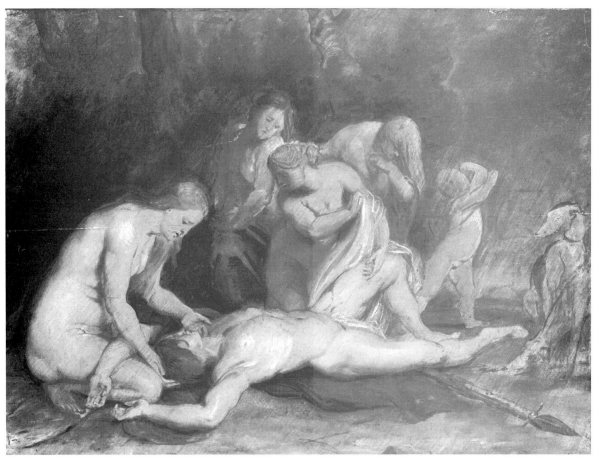

Fig.11 After cleaning, before restoration.

scratches, most noticeable in the right shoulder of the uppermost figure and at the left edge in the centre. The join had some darkened old restoration on the slight step on the left, running into the shoulder of Venus and there were more recent retouchings on the join and small losses. The paint on the addition has darkened and does not match the original in either colour or tone.

The varnish was a little discoloured and yellow, subduing the subtle colours of the original. There was also some surface dirt.

Treatment

The discoloured varnish and old restorations were removed with a mixture of Propan-2-ol and white spirit in the proportion 2:1. The old filling material was removed mechanically where it covered original paint. The blisters were secured with a 5% solution of isinglass. Some small old unfilled paint losses were then filled with fine-surface Polyfilla and an isolating layer of dammar varnish was brushed on (Fig.11). The inpainting of losses was carried out with dry pigments in Laropal K80.

During retouching a small blister appeared at the top edge of the original panel on the left and was secured with a wax/resin mixture (70% beeswax and 30% Laropal K80 resin). It is possible that further blisters will appear in due course and this area will need to be monitored.

A final layer of dammar varnish was sprayed on. The addition at the top is well attached and is causing no problems in the original panel. It was therefore left, but is now hidden by the frame which was adjusted accordingly.

Fig.15 No.4 after cleaning, before restoration.

DAVID TENIERS THE YOUNGER (1582–1699)

In these two paintings the aspirations of the founders of the Dulwich Picture Gallery are neatly epitomised: they represent the determination of Bourgeois and Desenfans not only to show the artists most admired at the time, but to create, by the judicious addition of canvas at the top and bottom of an inappropriately small painting, a pair of pictures where no such match previously existed. The reputation of David Teniers in the eighteenth and early nineteenth centuries was outstanding: in 1776 a Teniers fetched the highest sum ever paid for a painting at a Paris or London auction. The artist was central to the taste of the eighteenth-century aristocratic collector, being admired for his colour and composition, his facility with the brush, his understanding of character, his humorous observation, as well as for his skill in presenting low life scenes: it was remarked by Sir George Beaumont in 1817 that 'while looking at the pictures of David Teniers you thought of a man of Gentlemanly manners.' The founders of the Dulwich collection were aiming to assemble works which would represent the most admired artists of the time, but were anxious also to include works that were evidently expensive and prestigious. In acquiring pictures supposed to be by Teniers in such numbers – 22 paintings out of a collection of 356, outnumbering the supposed Cuyps and Poussins – they fulfilled this objective. Of the Teniers in the collection, these two pictures must have been considered among the prizes by virtue of their size, and of the fact that the artist himself was supposedly represented in no. 5. The desirability of giving this artist a prominent place in the display no doubt encouraged the decision, presumably by Bourgeois, to make no. 4 a pendant to the other picture which was of a suitable size for gallery display, and to place the two works in matching frames: a decision which was to create problems for the twentieth century conservator.

The role of 'Teniers' in the assembly of artists was complicated by the idea that the father (1582–1649) and his more famous son (1610–90), whose career as court painter and curator to the Archduke Leopold William, Regent of the Netherlands, was well chronicled, had produced a broadly comparable number of works. At Dulwich, the pictures were divided in the early catalogue of the 1820s between nine for the father and thirteen for the son. Although the importance of the father was discounted in J. T. Smith's *Catalogue Raisonné* of Teniers, of 1831, the hypothetical role of the elder man was maintained in the 1892 catalogue by J. P. Richter, and in the 1914 catalogue by E. T. Cook which still attributed twice as many pictures to Teniers the elder. These two paintings, and particularly *The Castle and its Proprietors*, continued, however, to be regarded as the work of the son. A further legend was offered in the story that Teniers was himself represented in the painting, in front of his castle where he executed many of his finest works.

These pleasant undemanding canvases with their blond tonality and their representation of both courtly and peasant scenes, were much admired when the Gallery opened. For P. G. Patmore, in *The Beauties of the Dulwich Gallery* of 1824, pictures of this class were 'highly interesting, from their purity of tone and facility of handling, as well as for that air of perfect nature . . .'. In the 1840s they received a less enthusiastic reception from John Ruskin. In *Modern Painters*, he commented of no. 5 that 'It has no tone contour or character of the soil of nature, and yet I can scarcely tell you why, except that the curves repeat one another, and are monotonous in their flow, and are unbroken by the delicate angle and momentary pause with which the feeling of nature would have touched them . . . all is mere sweeping of the brush over the surface with various ground colours, without a single indication of character by means of real shade.' It is a change of attitude from which the artist has scarcely recovered; but in the context of the Dulwich collection the two works retain considerable historical importance. It may well be that paintings which display such benign but non-ambiguous and calm qualities as these two will regain their former popularity for a generation less avid for tension than our own.

4 David Teniers the Younger

Peasants Conversing

Canvas, relined 70.8 × 172 cm. Additions of 40 cm to the top, 18 cm to the bottom and 5 cm to the right edge bring the overall stretcher size to 130 × 177 cm.

Signed (lower centre, on rock): DT.F, the DT in monogram

DPG no.76

Bourgeois Bequest, 1811

CONSERVATION REPORT

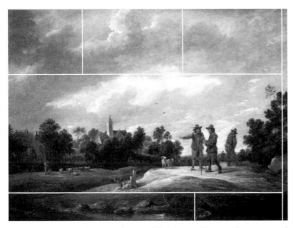

Fig.12 Diagram showing later additions to the top, bottom and right edges.

Examination and analysis

The original canvas was found to have substantial additions at the top and bottom of 40 and 18 cm respectively and a small addition on the right of 5 cm. The fillings along the joins between the central portion of canvas and the additions were lifting.

The addition at the top is made up from three separate pieces of canvas, that at the bottom from two pieces (see Fig.12). For reasons given below it was clear that these additions were not made by the artist, but by a subsequent owner of the picture, probably Sir Francis Bourgeois.

The resulting composite of seven separate pieces of canvas had been stuck down with a mixture of glue and paste onto a lining canvas and placed on an odd cannibalised stretcher made with old stretcher pieces. Cut-off stubs of horizontal cross bars protruded from the side members of the stretcher, while the top corner joints were held together with rectangular metal plates screwed to the wood (this stretcher was replaced in relining).

The central portion of canvas is of a medium grade with a fairly open even weave; the additions and the lining are of a similar grade, but with a closer even weave. In the X-ray the central portion of canvas shows 'cusping' on all four sides (i.e. the undulating distortion in the weave which occurs at the edges of a canvas when it is first attached to a stretcher). It has thus in the past been stretched on its own stretcher. There are moreover tack holes at the top and bottom of the central portion of canvas, visible in the X-ray, which do not correspond to the cusping. It would seem, therefore, that this piece of canvas had been on at least two stretchers before the additions were made.

The X-ray also reveals fundamental differences between the central portion of canvas and its additions. The fact that some of the canvas pieces are generally darker in the X-ray than others implies that they have different ground preparations. This was confirmed by analysis of paint samples. Samples taken from the original canvas show a chalk ground (which looks yellowish in the cross-sections owing to the discolouration of the medium). Above this is a grey priming with large splinter-like particles of charcoal black and lead white. The additions have different ground preparations. The top right piece has a red ochre ground overlaid with yellow ochre; the other additions at the top have one red ochre layer; the additions at the bottom both have a different thick bright red ground.

In the top right addition the X-ray revealed the head of a child and it would seem, therefore, that this piece of canvas was cut from another painting (Fig.13). In fact all the canvas pieces at the top had a layer of varnish beneath the sky paint and thus could all come from the same picture. The additions at the bottom, on the other hand, seem to have been made with fresh canvas.

For various reasons, therefore, it was clear that the additions were not original. Analysis of paint samples helped to establish the date at which they must have been made. Samples from both the top and bottom additions contain particles of Prussian blue, a pigment which was not introduced until c.1720. Moreover, the agglomerated particles of Prussian blue, as well as the nature and size of the other pigment particles and the nature of the ground preparations, suggest the additions were made before the nineteenth century.

It seems probable in fact that these additions were made by Sir Francis Bourgeois in the early years of the nineteenth century. Their effect is to bring Teniers's original to approximately the same size as *A Castle and its Proprietors* (No.9 below) which was acquired by Bourgeois in 1801 and the intention was presumably, therefore, to make a matching pair.

The painter responsible for the additions, probably Bourgeois himself, carried his work over onto Teniers's original which, in the upper part of the sky, has been substantially overpainted with the same clouds as in the upper addition. Thus, although the original sky by Teniers is bright after a shower of rain, it was overpainted at the time of the additions with heavier storm clouds. The

Fig.13 X-ray detail showing a child's head underlying the upper paint layers in the top addition at the top right-hand corner.

Fig.14 Sir Francis Bourgeois (1756–1811), *Seashore*, canvas, 101 × 106.3 cm. Dulwich Picture Gallery (no.335).

Seashore by Bourgeois (Fig.14) has a sky painted in a very similar way. The infra-red photograph also revealed that the thin tree on the right has been enlarged, presumably at the same time.

Although the landscape and figures are generally in good condition, with only slight wear, attempts have been made at some stage to remove the overpaint in the sky. This has resulted in considerable abrasion revealing the canvas weave in the grey underlayer. There are also fine sharp lines cutting into the paint where a pointed tool has been used to scrape the overpaint. These abrasions had in turn been retouched and the retouchings had blanched and discoloured.

In addition to the later overpainting of the sky other changes to the appearance of the picture have taken place simply as a result of ageing. The lower addition has darkened and no longer

matches the original. Paint samples taken from grey and blue areas of the original sky show in the first case a mixture of lead white with a fine black pigment and in the second case a mixture of smalt with white. The blue pigment smalt has a tendency to fade and that may be the case here. The brownness of the trees is perhaps the result of a discolouration of a copper resinate type green pigment. Before treatment the varnish was also moderately discoloured.

Treatment

The varnish and blanched feathered retouching in the sky were removed with mixtures of Propan-2-ol and white spirit and Acetone and white spirit, both in the proportion 2:1 (Fig.15). The older overpaint could not easily be removed without risk to the original paint. For this reason and for historical considerations (see below) it was decided to leave it. The raised areas of paint were consolidated with isinglass solution and, after facing, the old lining was removed. A paper backing was revealed on the additions, which has old worm holes and is inscribed with lines and illegible scribbles in blue/black chalk. A letter *b* in ink was also revealed on the back of the original canvas. The paper was left in place and the canvas was relined onto linen canvas with a glue/paste adhesive and placed on a new adjustable stretcher. Small losses in the joins were filled with fine-surface Polyfilla (chalk/PVA) before the application of an isolating layer of Laropal K80 varnish. Paint losses and numerous small abrasions in the sky were inpainted with dry pigments ground in Laropal K80. The transition between the original sky and the scraped areas in the overpaint was adjusted by careful toning and minimal retouching. The foliage added to the tree on the right was touched out. A final Laropal K80 varnish was sprayed on.

The restoration raised the interesting aesthetic and ethical question of whether the later additions should be concealed by folding them back or whether they should be left. The painting no longer appears as Teniers intended, but respect for the artist's intentions had to be balanced against the status of the painting within the context of the Dulwich collection. In the group of paintings bequeathed by Sir Francis Bourgeois in 1811, the painting has always been known in its present proportions, with the additions which bring it to the same size as the other large canvas by Teniers in the collection (No.5 below). However, Teniers's original painting was of the long, low format which he chose on a number of occasions, for example in the *View of 'De Dry Toren'* in the Wellington Museum at Apsley House. The paintings from the Bourgeois Bequest as a group constitute an important historical survival. Therefore, after much debate, it was decided that the additions should not be removed and that the proportions should be left as they had been in Bourgeois's collection.

5 David Teniers the Younger

A Castle and its Proprietors

Canvas, relined, 112 × 169.1 cm

Signed (lower centre, on rock): DT.F, the DT in monogram

DPG no.95

Bourgeois Bequest, 1811

CONSERVATION REPORT

Previous recorded treatment

In 1870 the picture was relined, 'revived' and re-varnished. It was again treated by Hell in 1948–53.

Examination and analysis

The lining canvas, which adheres very strongly to the original canvas, remains sound though it is stiff and taut with thick glue, the stiffness probably resulting from a high proportion of animal glue in the adhesive mixture. It seems likely that some of the threads of the original canvas were damaged or pulled out during the previous relining. This would account for several shallow narrow troughs in the surface, which are especially noticeable in the lower part of the sky on the left and under the right foot of the pointing bearded figure, extending through his left foot and across the lady's skirt. In several areas the edges of the craquelure overlap slightly, indicating that the original canvas has shrunk, preventing the paint from lying flat. It is probable that this occurred during lining because of excessive moisture in the glue. In addition there were numerous small raised paint blisters, especially in the sky, some of which were a little unstable.

Analysis of paint samples revealed a white chalk ground which appears buff in the cross-sections because of discolouration of the medium. Above the ground is a grey layer which can be seen in abraded areas of the sky and landscape. The blue in the sky is smalt, which has discoloured in some areas, and the blue in the costume is good quality azurite.

The trees and landscape on the right have a greyish, blanched appearance. A paint sample from the trees contains a quantity of chalk and an organic brown pigment which is probably Cassel earth. The chalk is probably the substrate for a yellow-lake pigment which has since faded, leaving the grey-brown appearance (see also p.48). Originally the trees would probably have been a translucent yellow brown. There is also considerable abrasion in the right part of the landscape and a brown layer seems to have been largely lost in the shadows. It is better preserved where it is thicker around the heads of the figures covering *pentimenti*.

Paint losses around the edges of the sky and an old tear in the lower part of the sky on the right have been filled with a very hard grey filling material. In all these areas the old restoration has darkened. There were also more recent losses around the edges filled with gesso. The retouchings to these losses and to the abrasion in the sky were blanched and mismatched.

There are several *pentimenti*. The heads of the figures have been lowered slightly and the pointing arm of the bearded figure has been shortened and lowered slightly. The positions of all of the feet and of the bottom of the red cape have been adjusted.

The varnish was moderately discoloured and yellowed. In the shadows of the landscape, especially on the right, areas of bloom in the varnish contributed to the grey, blanched appearance.

Treatment

The varnish and easily soluble retouchings were removed with a mixture of Propan-2-ol and white spirit in the proportion 2:1 and Acetone and white spirit in the same proportion. The hard old fillings and retouchings around the edges could not be removed without risk to the original paint and were left (Fig.16).

The raised blisters were laid with a gelatin solution and in some cases further consolidated with a wax/resin mixture (70% beeswax and 30% Laropal K80 resin). Removal of the varnish reduced the grey appearance of the landscape, but some areas of blanching remained. Some of the blanching, especially in the left side of the landscape above the pond and in the central landscape, was reversed with a mixture of industrial methylated spirit, diacetone alcohol and Cellosolve acetate in the proportion 4:1:1. However, in the landscape on the right, this treatment had only limited effect since the blanching is here largely due to fading of a lake pigment.

An isolating layer of Laropal K80 varnish was brushed on. A few small unfilled paint losses were filled with fine-surface Polyfilla (chalk/PVA) and the losses, areas of abrasion and old retouchings at the edges were inpainted using dry pigments ground in PVA (poly-vinyl-acetate). Final glazes in these areas and some slight toning in the blanched areas of the landscape were carried out with dry pigments ground in Laropal K80. A final layer of Laropal K80 varnish was then sprayed on.

Removing the discoloured bloomed varnish and the mismatched restoration considerably improved the appearance of the painting. Although the paint surface has been damaged and abraded, especially in the sky, the solid design combined with Teniers's confident technique still give the painting a strong impact. The advantages and disadvantages of relining the canvas were discussed and the decision was reached in this instance not to reline. In relining the stiff glue would have been removed and this might have allowed the original canvas to relax and accommo-

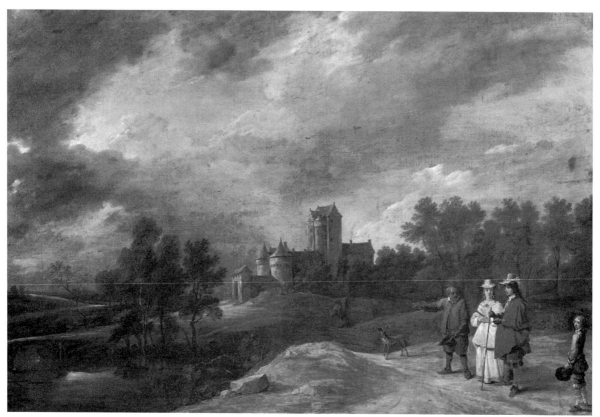

Fig.16 After cleaning, before restoration.

date the paint surface more satisfactorily, reducing the raised and overlapping areas. However, the lining remains sound and the adhesion between the two canvases is very strong. The troughs in the paint surface indicate that the back of the original canvas has been damaged and weakened and removal of the well-glued lining would put considerable stress on the original canvas and thus also on the paint layers. There was thus no wholly satisfactory solution to the painting's structural problems. Within the controlled environment of the Gallery, the painting should remain stable.

6 Bartolomé Esteban Murillo (1617–1682)

The Madonna of the Rosary

Canvas, relined, 201 × 128 cm

DPG no.281

Bourgeois Bequest, 1811

The rosary which the Christ Child holds up for our attention suggests that the *Madonna of the Rosary* may have been painted as an altar-piece for a Dominican chapel, since the use of the rosary to count the sequence of prayers to the Virgin Mary was first instituted by the Spanish Saint Dominic. Usually the Virgin or Child is shown holding out the rosary to S. Dominic, as in Murillo's earliest known painting *The Virgin presenting the Rosary to S. Dominic* of 1638–40 for the Dominican Monastery of Santo Tomás (now in the Archbishop's Palace in Seville). Instead, the Dulwich altar-piece shows the Virgin and her Child alone, seated in celestial glory on a throne of clouds being gently pushed heavenwards by a group of playful cherubs, set against a background of scudding clouds, which grow ever more golden towards the top of the canvas. By omitting the usual terrestrial lower order of saints, the scene is presented as a purely devotional image rather than as a narrative. Although Spain had a popular tradition of devotion to the Virgin Mary, which was exceptionally fervent in Seville, the practice of picturing the Virgin and Child alone was not as common as it was in Italy. Like Raphael before him, Murillo had a flair for interpreting the devotional image of the Virgin and Child. His representations were imbued with religious feeling and with a naturalism which embraced both female beauty and infant charm. The playful way in which Christ toys with the rosary is a characteristic Murillo touch which adds an appealing, human and familiar gesture to a grand religious painting. The Christ Child's parted hair adds a further sign of domesticity. Their quiet contemplative gazes provide an intimate link between the celestial vision and the worshipper, who would literally have viewed this altar-piece from below. The pensive, abstracted look of their faces gives a melancholy expression to their delicate features. They appear to look fixedly at the spectator and yet also survey another world beyond. Their fair complexions create what would have seemed to Murillo's Spanish contemporaries, as well as later British commentators, an idealised maternal couple. The altar-piece provided a graceful blend of naturalistic and idealistic elements; its celestial vision existed in its own right, its divine figures commanding our attention and devotion, which was their spiritual function.

The altar-piece, painted late in Murillo's career probably in the second half of the 1670s, demonstrates his mature so-called 'vaporous' style, in which light seems to suffuse the whole composition and soften its forms. The paint was applied in a loose manner, worked up into a display of great technical virtuosity in the Virgin's gauzy veil and the illuminated folds of her sleeve and drapery. The graceful style and refined colouring were suitable for a celestial subject such as the Madonna but also anticipated the taste of the following century. The end result was a decorative, delicate style expressed pictorially in an accessible and tender manner, which both reflected a sincere piety and exerted an authentic popular appeal for over two centuries.

During the eighteenth and nineteenth centuries Murillo enjoyed great popularity, his name better known than that of his Seville compatriot Velázquez. British collectors, painters and commentators on art particularly appreciated Murillo's work and several of his paintings were imported in the eighteenth century by British diplomats. The *Madonna of the Rosary* was brought back by Alleyn Fitzherbert (1753–1839), later Baron St Helens, who acquired paintings and drawings by Murillo while Ambassador Extraordinary to Spain in 1791–4. A copy of the Dulwich Madonna (at Corsham Court, Wiltshire) had been imported by another ambassador to Spain, Sir Paul Methuen (1672–1757).[1] British commentators often ignored the devotional nature of his Catholic imagery and concentrated on the spontaneity of his figures and the natural expressiveness of their attitudes. Paradoxically his popularity led to a fall in his reputation, partly encouraged by the effect of his many imitators and copyists in Spain and the quantity of cheap reproductions which debased his imagery. The decline steepened in the twentieth century as modern taste moved away from the representation of gentle, contemplative emotions towards more aggressive images. To modern eyes his work appeared sentimental. Although it had been Murillo's pictures of beggar children which earned him especial popularity in Britain, his Catholic devotional images also attracted admiration for their abstract spiritual qualities and their expression of divine contemplation. The eyes of the Dulwich Madonna and her Child particularly enthralled the Victorian poet Alfred Tennyson, who referred to their fixed gaze 'but they seem to look at something beyond – beyond the Actual in to Abstraction. I have seen that in a human face.'[2]

Xanthe Brooke

1 D. Angulo Iñiguez, *Murillo: su vida, su arte, su obra*, 1981, II, p.152.
2 Hallam, Lord Tennyson, *Tennyson and his Friends*, 1911, p.143.

Previous recorded treatment

The reverse of the lining canvas before treatment bore the inscription 'LinD [lined] by T.S.' referring to an earlier treatment which is otherwise unrecorded. The picture was treated by Hell in 1949–53.

Examination and analysis

The canvas is a very fine linen of a non-uniform twill-type weave and, unusually, retains its original tacking edges (Fig.17). It had been glue-lined onto a fine plain-weave linen canvas in two joined lengths, the vertical seam causing a raised line in the paint surface. The lining canvas had become weak and brittle and distortions to the original canvas had been caused both by a twist in the stretcher at the top and bottom and also by the fact the canvas had become stuck to the stretcher by excess lining glue. The canvas also had two major tears, top left and lower right, of which the former was raised.

The paint layers seemed secure, but the surface was cupped and uneven. In addition an earlier relining had caused a flattening of the impasto and 'moating' where impasto had been pressed into the surface.

In certain areas the paint exhibited a degraded and blanched appearance, especially in the dark blue and greys of the background and in the blue draperies. In the last a brown layer is visible which may contain degraded smalt. In areas of the background, notably lower right, there were also white splash marks which have affected the paint layers.

There were several areas of damage, which had been retouched, and numerous small retouchings mainly to craquelure and abrasions. All these retouchings had discoloured, some darkening, others becoming light and 'chalky' as in the faces of the Virgin and Child.

Around the edges of the painting on all four sides were lines of evenly spaced pinholes, which were later found to extend through both the original canvas and the lining canvas. These were apparently made once the paint was dry, but their purpose is unclear. They possibly relate to a previous restoration or perhaps to a framing method.

The varnish had yellowed and was very degraded with areas of crazing and blanching and a generally opaque and greyish appearance.

Examination under ultra-violet light indicated an unevenness in the thickness of the varnish which suggested a selective cleaning in the past, more varnish being removed in general from the lighter areas.

Fig.17 Detail of the reverse of the original canvas.

Treatment

The discoloured varnish was removed using a mixture of industrial methylated spirit and white spirit in the proportion 1:4. Old putty fillings and overpaint were softened with Laponite gel (a synthetic clay) and removed mechanically. The partially degraded blue drapery of the Virgin's robe had been coated with a very soluble tinted green layer. The layer did not follow the modelling of the original paint and was designed to reduce the worn appearance of the original. This was removed using the same mixture as was used to remove the varnish (Fig.18).

Before relining the paint surface was consolidated with a thin coat of Beva 371. After facing, the tacking edges were unfolded and partially flattened and the stretcher bars which were stuck to the lining canvas were released. The old lining canvas, which adhered poorly to the original, was removed as was the lining adhesive. When the facing was removed some of the paint around the edges was found to be insecure, probably as a result of a release of tension when the stretcher bars were removed, and was consolidated with Russian sturgeons' glue. Holes in the original canvas were repaired with canvas insets taken from the original tacking margins and the tears were joined, in both cases using polyamide resin adhesive. The painting was then lined on fine linen canvas using Beva 371 adhesive and further treatment was carried out to ensure a good bond and to reduce the cupping of the surface. It

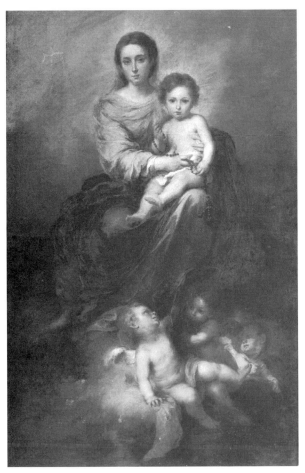

Fig.18 Before present treatment.

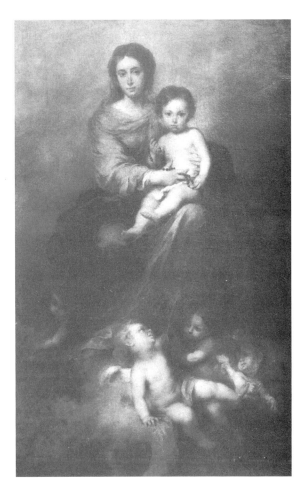

Fig.19 Before treatment of 1949-53.

was placed on a new stretcher with a loose-lining of acrylic-primed linen canvas added as a barrier to fluctuations in relative humidity.

The painting was then varnished with MS2A resin varnish. Losses were filled with a chalk-gelatin putty, which was textured to match the original, and retouched using dry pigments in an egg tempera medium, with MS2A resin glazes. MS2A resin was also used for the reintegration of worn and degraded areas such as the blue drapery. A final coat of MS2A resin varnish was applied after retouching.

Discussion

The painting arrived for treatment coated with a varnish that had aged to form a greyish and slightly opaque layer over the paint. More dis-figuring than this were the dozens of discoloured retouchings of previous restorations, which necessitated the cleaning of the painting. Once the varnish had been removed, three restoration campaigns could be identified. Interestingly, a previous restoration had included the re-modelling of the Virgin's hair, probably to reflect the taste of the time. There was no trace of this

overpaint when the present treatment began, but it can be seen in old photographs (Fig.19).

Once the painting had been cleaned, the condition of the paint layer could be reassessed. Areas that contain a high proportion of lead white pigment, such as the flesh tones, are in very good condition, particularly good examples being the face of the Virgin and the foremost cherub. However some areas, in particular the dark greys and grey-blues in the background, are leached and porous and prone to blanching.

The condition of the paint film results from numerous restorations and the natural ageing of the materials, which has been disfiguring in some areas. The most significant example is the blue drapery of the Virgin's robe. Analysis of cross-sections shows that the blue drapery was painted using smalt in the lower layers and ultramarine for the intense highlights.

Smalt is a potassium glass coloured blue by the addition of cobalt oxide obtained by roasting cobalt ore. Smalt used in an oil medium often loses its blue colour, becoming brownish in time. There are various reasons for this discolouration. Firstly, being a glass, the pigment has a low tinting strength, with a similar refractive index to oil. This

43

means that when the oil medium darkens with age, the colour of the pigment is overcome by the yellow-brown of the medium. Secondly, there may be excess alkaline material in the pigment, originating from the potash in the glass, which could react with the oil medium causing it to break up and become brown. Lastly, the cobalt ions may migrate from within the smalt particles to add to the reaction with the oil medium causing discolouration of the pigment. This can sometimes be seen in samples of paint containing smalt particles which have lost their colour around the edges, retaining a blue core.

Smalt seems to have been a common feature of Murillo's palette, and his work has often suffered this type of degradation. In the Dulwich picture, the pigment has been used extensively both in the blue drapery of the Virgin's robe and in the swirling light and dark grey-blues in the lower part of the picture. In both cases the paint medium appears more broken up and prone to blanching than other areas of the painting. In the drapery, the deterioration of the smalt-containing layers has left the mid-tones and shadows brown and abraded, whereas the ultramarine is much better preserved. It is noteworthy, and perhaps a reflection of his success as a painter and the value of the commission, that Murillo has used ultramarine at all – in his treatise of 1649, Francisco Pacheco famously stated that the pigment 'is neither used in Spain nor have the painters enough wealth to use it'.

The worn appearance of some areas of the paint film may additionally have been caused by aggressive cleaning methods in past restorations. In some places the paint film is pitted with tiny voids, as if it has been attacked by a caustic material. It is likely that the degraded smalt-containing areas have been over-zealously cleaned in the past, perhaps in an attempt to uncover a better blue colour, and the broken-up medium would have been vulnerable to strong reagents and abrasive methods.

The appearance of the painting was also marred by the marked cupping in the paint layers. The painting had been lined, c.1800, with a very thick glue layer, and this was embrittled to the extent that it could no longer support the original painting adequately, or keep the paint in alignment. The lining process has also irretrievably flattened impasto and the tops of raised craquelure. Once this lining had been removed the painting could relax and the surface improved slightly. During the relining of the painting the cupping was reduced further.

Once the old lining canvas was removed it became clear that Murillo has used a remarkable twill damask canvas with a complicated pattern for this painting. The design consists of alternating diamond and cross motives within an undulating checked pattern. This would have been complex to weave and so must surely indicate that the fabric is of very high quality.

A dark red-brown coating was found to have been applied to the back of the canvas, probably consisting of a red earth pigment in an oil medium. While this is probably not original (it did not appear to extend below an old patch over the damage above the Virgin's head) it dates from early in the painting's life, before the last lining and before a previous treatment which included the patching of the large tear in the upper left-hand side. It may have been applied as a partial moisture barrier to help prolong the life of the original canvas.

The application of this layer provides some clues relating to the way in which the painting was supported in the past. It does not extend to the very edges of the canvas, suggesting that it was applied while the painting was attached to a stretcher. However, the uncoated gap seen at the right hand edge of the canvas (known to be complete) is not wide enough to allow for the width of a stretcher bar and that of a tacking margin and so the painting was perhaps nailed to the front edge of a 'strainer'.

A thick dark reddish-brown ground has been used by the artist, containing earth pigments, quartz, black, chalk and gypsum as the main extender, in an oil medium. Seventeenth-century Spanish treatises on painting describe various forms of canvas preparation. The older method consists of a liquid flour, oil and honey mixture called 'gacheta' or 'gacha' applied first, followed by red earth ground in oil. Variations include the use of a gypsum-based gesso instead of the 'gacheta' or simply a layer of size applied first, followed by red earth ground in oil. Murillo has used a method that combines the use of gypsum with that of an oil and earth priming. The result is a thick and seemingly porous layer.

No underdrawing can be seen either with the naked eye or by infra-red reflectography, and the design was probably sketched in the paint layer using preparatory drawings. There are very few *pentimenti*, the most important being a change in position of the Child's right arm, hand and the rosary beads he holds. The confident manner in which the painting has been executed and the apparent lack of underdrawing are perhaps an indication of Murillo's assurance in painting such subjects at this late stage of his career.

Fig.21 Aelbert Cuyp, *River Landscape with Horsemen*, canvas, 128 × 227.5 cm. Rijksmuseum, Amsterdam (A4118).

AELBERT CUYP (1620–1691)

Dulwich Picture Gallery possesses one of the most extensive holdings of paintings by the Dutch artist Aelbert Cuyp and, equally remarkably, all belonged to Noel Joseph Desenfans by 1807, and perhaps considerably earlier. Both Desenfans and his close friend Sir Francis Bourgeois loved Cuyp. In Desenfans' house in Charlotte Street, a 'Cuyp Room' was devoted exclusively to works by the artist. Its contents are shown in a diagram which accompanied the inventory drawn up in 1813 by John Britton (Fig.20). Only Poussin was similarly honoured with a separate gallery. As a dealer in Old Masters, Desenfans handled many important pictures by Cuyp. In 1788 he bought two Cuyp landscapes from the Paris dealer Jean-Baptiste-Pierre Lebrun which had probably come from the famous sale of Johan van der Linden van Slingeland's collection, held in Dordrecht in 1785.

When Desenfans began to assemble a collection of paintings for a national gallery in Poland, Cuyp was prominently represented. Works by the Dutch artist had enormous appeal for British connoisseurs of the late eighteenth century for it seemed that the elegance of his imagery and the precision of his naturalism conformed closely to the expectations of upper-class, especially aristocratic, collectors. The British art market discovered Cuyp's works comparatively late. Totally unknown in the seventeenth and early-eighteenth centuries, the demand for Cuyp suddenly blossomed in the late decades of the eighteenth century. Along with dealers such as John Bertels and Michael Bryan, as well as collectors like the 3rd Earl of Bute, the 3rd Earl of Bridgewater, and the Prince Regent, Desenfans played a major role in the discovery of Cuyp.

After the fall of Poland in 1795, Desenfans was left with a large collection of paintings. He sold a major painting by Cuyp to John Joseph Martin of Ham Court for 350 guineas in 1796 (Fig.21, now in the Rijksmuseum, Amsterdam). The rest of the collection was exhibited for private sale in 1802, then placed on the auction block but, in the face of much criticism, almost everything went unsold. Sir Francis Bourgeois continued to buy paintings by or attributed to Cuyp and his own landscape style was influenced, at least in part, by Cuyp's pictures. Further, on at least three recorded occasions, he retouched and repainted works attributed to Cuyp (cf. also No.4 above). At the time of Bourgeois' bequest to Dulwich College, nineteen paintings were called Cuyp. The vicissitudes of connoisseurship and art history have led to the reassignment of many of these to other artists, including Cuyp's principal follower Abraham van Calraet (1642–1722). Today there are six firm attributions to Aelbert Cuyp, a total exceeded only by the holdings of the National Gallery in London.

Cuyp's early landscape paintings were produced under the influence of Jan van Goyen who had favoured free, sketchy brushwork in muted tones of brown and green. The earliest picture by Cuyp at Dulwich, *Landscape with Cattle and Figures* (Fig.22), is painted in this style. Cuyp often depicted shepherds at rest, gazing out over an

45

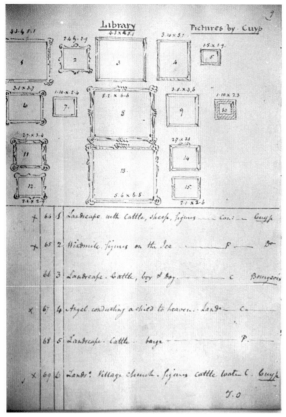

Fig.20 The 'Cuyp Room' at 38–39 Charlotte Street, from John Britton's inventory, 1813. Dulwich College archives.

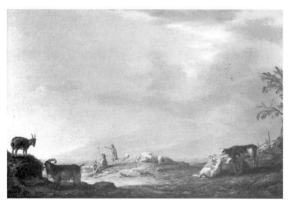

Fig.22 Aelbert Cuyp, *Landscape with Cattle and Figures*, oak panel, 40 × 59 cm. Dulwich Picture Gallery (no.348).

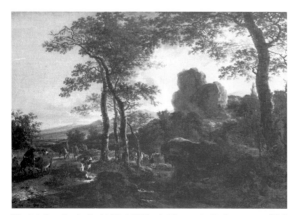

Fig.24 Jan Both (c.1615–1652), *A Mountain Path*, canvas, 70.8 × 111.4 cm, Dulwich Picture Gallery (no.208).

extensive panorama, and he repeated the motif quite closely in *View on a Plain* (No.7) which dates from about 1644, a few years after Figure 22. Cuyp's broken brushstrokes are now tempered by a golden sunlight which casts stronger shadows throughout the scene. Although Cuyp himself never visited Italy, the rich, smoky atmosphere was borrowed from the paintings of Jan Both (c.1615–1652) and other Dutch painters who did. This particular work was painted just as Cuyp was becoming concerned with warm colouring and idyllic scenery.

In the distance, the magnificent church of St Cunera towers over Rhenen, a small town perched on hills above the Rhine. Dutch landscapists, including Hercules Seghers, Jan van Goyen, Salomon van Ruysdael, and many others, had long been attracted by the great beauty of the locale just east of Utrecht and perhaps also because Rhenen was the residence of the Winter King and Queen of Bohemia, more correctly, Friedrich V, Elector of the Palatine, and his wife Elizabeth Stuart, sister of Charles I. The King had been installed in Prague for less than a year (hence his nickname) but was celebrated in the Netherlands as a Protestant military hero, as well as a relative of the Prince of Orange. Amalia van Solms, consort of Frederik Hendrik, had come to the Netherlands as lady-in-waiting to the Winter Queen.

Aelbert Cuyp visited and sketched Rhenen as early as 1641, when he made a topographically faithful drawing which is preserved in the Teylers Museum, Haarlem (Fig.23). Besides the painting at Dulwich, Cuyp employed the view in several other paintings.[1] He used two other drawings to construct the composition – a sketch of the standing shepherd and another of some of the sheep (both private collections, The Netherlands).[2]

Only slightly later in date is *Herdsmen with Cows* (No.8), a painting where the influence of Jan Both can be even more strongly felt. The topography and atmosphere seem now completely meridional. Long shadows punctuate the scene and sunlight gilds the edges of leaves in the foreground. Spatial recession is remarkably accomplished by a heavy mist and the sweep of the countryside to distant mountains.

Celebrated and controversial in the nineteenth century, this painting inspired more comment than almost any other at Dulwich. P.G. Patmore in 1824 thought it exceeded nearly all other landscapes: 'It gives a more apt idea of the Golden Age of classical poets than all the classical works intended to typify it – even those of Claude and Poussin'.[3] Mrs Jameson and C.R. Leslie also heaped praise upon the picture. William Hazlitt thought it 'the finest Cuyp, perhaps in the world ... The tender green of the valleys beyond the gleaming lake, the purple light of the hills, have an

Fig.23 Aelbert Cuyp, *View of Rhenen*, graphite, black chalk, yellow and grey washes on paper, 19 × 30.5 cm. Teylers Museum, Haarlem (P42).

effect like that of the down of an unripe nectarine. Miles of dewy vapour are between you and the objects you survey'.[4] Such high-flown praise was sure to annoy John Ruskin who launched a famous attack on the picture for its observational inaccuracies: 'the sky of a first-rate Cuyp is very like an unripe nectarine: all that I have to say about it is that it is exceedingly unlike a sky'.[5]

The interest in this painting has been difficult to appreciate in the twentieth century, for blanching had obscured much of its atmospheric colouring. The recent cleaning and resaturation of the chalky areas have been especially welcome in revealing one of Cuyp's major achievements.

One of Cuyp's most imposing late works, *A Road near a River* (No.9) has similarly been rediscovered through careful cleaning. Unlike No.8, this landscape had been largely ignored by Victorian critics. This painting must have been one of Aelbert Cuyp's very last works, probably painted at the end of the 1650s or early in the following decade. Its complicated composition represents a departure for Cuyp. The trees which divide the road from the river and the mountain beyond animate the centre of the picture. This screen-like motif is derived quite literally from the landscapes of Jan Both (Fig.24) which were so influential on Cuyp. Although the scenery generally resembles the broad valleys of the Rhine, the topography cannot be specifically identified. Cuyp's italianate sunshine is at its most golden, the brilliance of the scene enhanced by the long shadows which fill the immediate foreground.

Like the other works by Cuyp at Dulwich, the landscape is inhabited by simple, happy peasants who live off the land. Men fish contentedly in the distance, two peasants sit at the side of the road, and the shepherdess elegantly points the way to a boy on a donkey, who seems to have been heading the wrong way. While Cuyp typically populated his landscapes with both aristocratic horsemen and peasants, this picture contains only rustics. Cuyp's paintings of patrician riders had great appeal for the residents of country houses, while the urban gentry favoured Cuyp's other subjects. It is fascinating that Desenfans preferred paintings by Cuyp which depict peasants only, rather than the more frequently encountered upper-class staffage. Cuyp's vision of happy and simple rural life must have had enormous appeal for Desenfans, who was so completely part of the urban world.

Alan Chong

1 The view of Rhenen also occurs in *A Portrait of a Family* (dated 1641, private collection, Switzerland) and *Horsemen overlooking Rhenen* (Hoogsteder and Hoogsteder, The Hague).

2 *Aelbert Cuyp en zijn familie: schilders te Dordrecht*, exh. cat. Dordrechts Museum, 1977–8, nos.59, 63 (both illustrated).

3 P.G. Patmore, *British Galleries of Art*, London, 1824, p.171 (first appeared in *New Monthly Magazine*, 1822).

4 W. Hazlitt, *Sketches of the Principal Picture-galleries in England*, London, 1824, p.30 (first appeared in *London Magazine*, 1822–4).

5 J. Ruskin, *Modern Painters, Their Superiority in the Art of Landscape Painting to all the Ancient Masters*, London, 1843, pp.187–8.

7 Aelbert Cuyp

View on a Plain

Oak panel, 48 × 72.2 cm

DPG no.4

Bourgeois Bequest, 1811

CONSERVATION REPORT

Examination and analysis

The oak panel is made up from two horizontal members joined at 24.5 cm from the bottom edge. The *verso* is bevelled on all four sides and the panel has a slight convex warp. At some stage the two members have been rejoined, the join then being covered on the back with a strip of canvas smoothed off with filling material and the whole of the back of the panel covered with black paint.

The panel has a white chalk ground covered by a thin light orange-brown priming of lead white tinted with a little black, umber and yellow earth. In the sky there is also a brownish-grey underpaint which is slightly lighter in colour than the priming. A sample showed that this layer contains lead white, some smalt and a little yellow and brown earth. The greyish-blue sky paint contains smalt mixed with lead white.

As with other works in this exhibition, the appearance of the picture has been affected by blanching. This is apparent in the greens of the foreground, which have a greyish appearance, and to a lesser extent in the trees behind the cows.

In a strip at the lower right edge, where the green paint has been protected from light by the frame rebate, there is no blanching. Paint samples from the protected and unprotected areas were compared. Both show two yellow-green layers. However, the sample taken from the unprotected, blanched area has a yellowish-white appearance in the upper part of the top paint layer, which indicates that the deterioration in the blanched areas is light-induced (see p.24 F,G). The paint layers contain yellow earth pigments, a small amount of lead-tin yellow and bone black, as well as a considerable amount of calcium, probably in the form of chalk. Chalk was a common ingredient in the manufacture of yellow lake pigments in the seventeenth century. It was used because the colouring matter in yellow lake pigments, which derives from organic plant dye-stuffs, needs to be precipitated onto an inorganic substance, such as chalk, before it can be bound with a medium and used as paint. Yellow lake precipitated on chalk is known to be particularly prone to fading[1] and this is almost certainly the explanation for the whitened appearance at the surface of the blanched sample (cf. also No.8 below).

Some blue-green areas of foliage in the foreground exhibit a localised, fine craquelure which seems to have affected only the uppermost paint layer. A sample taken from one of these areas showed a thin whitish layer on the surface which has cracked and partially cleaved from the layers below. Analysis identified this as a thin, faded yellow glaze.

When the two members of the panel were rejoined, it appears that the alignment was not perfect and the join had been extensively retouched. The retouchings had darkened in some places and lightened in others.

There were discoloured retouchings in various other areas. Retouchings in the sky above the join had lightened. In front of the cows were a number of discoloured green retouchings. To the left of the seated woman there was darkened overpaint covering a dip in the panel. In addition the craquelure in the blue trousers of the man was slightly raised and slightly unstable.

The varnish had darkened and was considerably discoloured.

Treatment

The varnish and more easily soluble retouchings were removed with a mixture of Propan-2-ol and white spirit in the proportion 2:1 and with an Acetone and white spirit mixture in the same proportion. The overpaint along the crack was partially removed with a 10% ammonia solution and then mechanically with a scalpel under magnification. Three separate earlier campaigns of retouching were distinguishable on the join and the overpaint extended considerably over original paint both above and below. The removal of these retouchings revealed spiral scratch marks in the surface and a flattening of the impasto in the sky where the paint surface was sanded down, presumably to disguise the slight misalignment in the two members of the panel (Fig.25).

The slightly unstable raised craquelure in the man's trousers and the craquelure in the blue-green foreground foliage were consolidated with a wax/resin mixture (70% beeswax and 30% Laropal K80 resin).

Tests were carried out to find a way of treating the blanching in the green and reversing the colour change. The application of varnish had no effect. Other tests with a mixture of industrial methylated spirit, diacetone alcohol and Cellosolve acetate in the proportion 4:1:1, and with mixtures of old linseed stand oil and white spirit in the proportions 2:1 and 1:1 also had no effect on the blanching.

Small old paint losses along the join and along the bottom were filled with a chalk/gelatin mixture and an isolating layer of dammar varnish was brushed on. Inpainting on the losses and the stain along the join was carried out with dry pigments ground in Paraloid B72. The paint losses

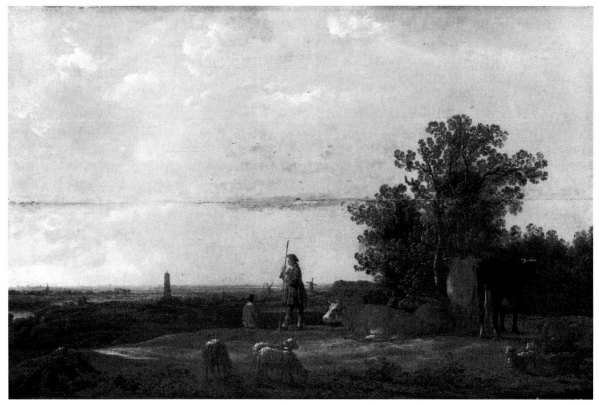

Fig.25 After cleaning, before restoration.

along the bottom were inpainted with dry pigments in PVA (Poly-Vinyl-Acetate). Paraloid and PVA were used because they cover well without creating a glossy surface. The final glazes were carried out with dry pigments ground in Laropal K80. The discoloured blanched areas were toned slightly with colour. A final coat of dammar varnish was sprayed on.

The appearance of the painting has altered with time, with the fading of the yellow lake in the green and with the abrasion of the sky during rejoining of the panel. However, the removal of the distracting old restorations and the light toning of the discoloured green have re-established the effect of evening light and Cuyp's fine and skilful craftsmanship is clearly evident despite the subsequent changes and damage in the paint surface.

1 See D. Saunders and J. Kirby, 'Light-induced colour changes in red and yellow lake pigments', *National Gallery Technical Bulletin*, 15, 1994, pp.79–97.

8 Aelbert Cuyp

Herdsmen with Cows

Canvas, relined, 101.4 × 145.8 cm

DPG no.128

Bourgeois Bequest, 1811

CONSERVATION REPORT

Fig.26 Photograph taken in raking light before treatment.

Previous recorded treatment

The picture was 'revived' and revarnished in 1867. Holder reported on the condition of the picture in 1911 and recommended relining, but there is no record of the treatment being carried out. The picture was again treated by Hell, 1949–53.

Examination and analysis

The canvas, which had been relined, possibly in 1911, was slack on the stretcher. A horizontal tear of approximately 12 cm at the top right corner had been unevenly filled and was beginning to lift. The painting is the original size and most of the turnover edges are still in place.

The paint surface was generally secure; however there were signs of incipient flaking particularly in the lower part of the sky. There was also a prominent, raised and disfiguring craquelure (see Fig.26).

Apart from the retouching of the tear there were also numerous very small retouchings in the sky. However, the appearance of the picture was most severely affected by blanching (i.e. a chalky, whitened appearance) in the foreground, including parts of the figures and cows, and in the mountain. Removal of the discoloured varnish revealed that the blanching was not simply a result of deterioration of the varnish, but occurred in the paint itself.

Paint samples were analysed to investigate the cause of the blanching. Samples taken from blanched green and brown areas showed complex mixtures of pigments based principally on yellow lake and bone black with some yellow earth and a little green earth. The presence of yellow lake, which is highly fugitive, suggested that a fading of the pigment might be responsible, at least in part, for the blanching. This was supported by the presence of a thin layer at the top of the surface of most of the samples, which appeared whitish and cloudy.

At high magnification, completely colourless particles could be seen at the top of the paint layer while a strong yellow colour was still present in the bottom half of the layer (see p.24, H). These colourless particles were found by EDX analysis to contain calcium, probably in the form of chalk. As stated above (see No. 7) chalk was a component often added during the manufacture of yellow

lakes, particularly in the seventeenth century, and is mentioned in recipes found in seventeenth-century treatises. These colourless calcium-containing particles at the surface are probably particles of yellow lake which have faded. In addition, the surface appears rough and the particles exposed and this may cause a scattering of light which would contribute to the blanched appearance.

Apart from the blanching, the paint samples also revealed an orange-brown ground preparation of a light colour consisting of lead white with some earth pigments. The sky was painted with a thin layer of lead white over the ground, then a light blue layer containing smalt and lead white. The smalt has discoloured to a slightly greyish colour.

Before treatment the varnish was also significantly discoloured.

Treatment

The varnish and retouchings were removed with a mixture of industrial methylated spirit and white spirit in the proportion 1:5.

The canvas was then faced with Beva 371 and eltoline tissue and the old lining canvas removed. The lining glue was removed using a scalpel (scraping with laponite RD thixotropic agent and water in suspension). The tear was 'stitched' using flexible epoxy resin. The facing was then changed to thinned lining glue and sulphite paper. The original canvas was pre-stretched on a loom and then ironed to improve the surface in areas of raised craquelure. It was then composite glue double-lined on Irish linen canvas. The stretcher was repaired and the painting restretched.

Following the analysis of paint samples (see above) various tests were carried out to find a method which would successfully treat the blanching. These involved the application of:
1. A standard solution of MS2A synthetic resin varnish in white spirit
2. Arkon P.90 synthetic resin varnish in white spirit
3. MS2A varnish with 5% linseed stand oil
4. Mastic resin 30% in turpentine

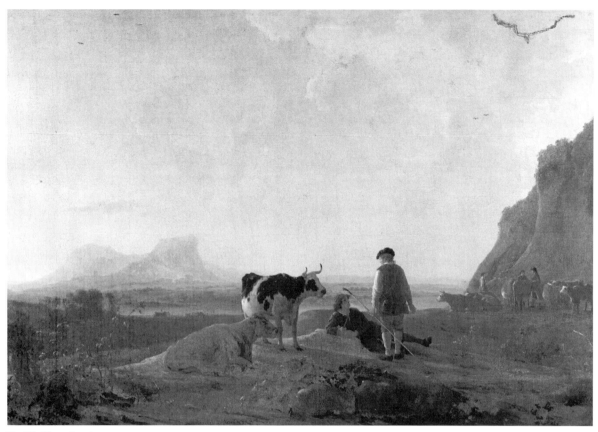

Fig.27 After cleaning

These mixtures were applied to small areas with a brush and removed after testing their effect. Each reversed the blanching and re-established the visual coherence of the test area, but the effect was only temporary. As the volatile components evaporated the blanching returned. It was therefore decided to make tests with the application of oil. Tests were made with linseed stand oil dispersed in white spirit and sun-bleached linseed oil similarly dispersed in white spirit, in various concentrations, as well as the application of each oil undiluted. Linseed oil was chosen in preference to poppy or walnut oil, and stand oil in preference to sun-bleached, because of the shorter drying time. The oil was dispersed in white spirit in order to achieve an appropriate viscosity, allowing saturation of the faded layer at the surface, and to minimise the amount of oil required to achieve a successful outcome.

The mixtures which proved most successful, both in achieving a sustained reversal of the blanching and in their shorter drying time, were mixtures of linseed stand oil and white spirit in the proportions 1:2 and 1:3. The 1:3 mixture was generally adequate, but the 1:2 mixture was required in certain areas of severe blanching. Small amounts of the linseed oil and white spirit

mixture were applied with a stiff brush, the excess being removed with a silk pad. After treatment the painting was exposed to daylight for a period of six weeks. At the end of this period, the paint was still reasonably saturated. A further film of MS2A resin varnish was then brushed on and further thin layers of varnish were applied selectively in certain areas to achieve an even saturation over the whole surface of the painting (Fig.27).

Retouching was then carried out using pigments bound in egg tempera and in MS2A varnish for the glazes. Finally two layers of MS2A varnish were sprayed on, the second layer containing a proportion of Cosmolloid 80H wax.

Undoubtedly *Herdsmen with Cows* has changed considerably since it left Cuyp's studio. As with all paintings, time has wrought irrevocable changes which affect the viewers' appreciation of the picture. In this case severe blanching not only made the picture difficult to read in passages, but was also quite unsettling. The viewer was preoccupied with the puzzle of the incongruous frosty foreground instead of enjoying the image as a whole. With cleaning and restoration it has been possible to redress the balance and recover to a considerable degree the quality of space and light in Cuyp's landscape and its sense of tranquility.

9 Aelbert Cuyp

A Road near a River

Canvas, relined, 113.2 × 168.8 cm (stretcher size 115.6 × 170.6 cm)

DPG no.124

Bourgeois Bequest, 1811

CONSERVATION REPORT

Previous recorded treatment

The painting was relined by Morrell and cleaned by Merritt in 1864. Flaking paint was secured with wax resin at the National Maritime Museum in 1977. The painting was then surface cleaned and the varnish revived, many of the discoloured retouchings were again retouched and a new varnish applied.

Examination

The paint surface was loose and tending to flake. The varnish was moderately discoloured and slightly opaque. In dark passages paint colour was blanched, notably in the dark foliage of the central trees, in the distant trees beyond the figures and in the foreground where the middle tones were missing. This made very dark original shadows under the outcrop of rock on the left and under the rocks on the right look like dark retouchings (Fig.28).

There were numerous small retouchings in the sky top left, on the clouds in the centre and top right where there was also some wear, and in the sunset, in the outcrop of rock lower left and at the lower left edge, and among the sheep, and in the mountains on the right. These retouchings had been re-retouched in 1977. There were also noticeable and disturbing cracks in the sky, especially above the mountain. Cleaning further revealed that the sunset had some time ago been greatly enhanced with yellow repainting beneath which were old damages and hardened retouching.

Treatment

The picture was cleaned before lining. This helps to ensure better conservation, as solvents can weaken a new lining. The varnish and soluble retouchings were removed with a mixture of Acetone and white spirit in the proportion 1:1. Stubborn retouchings and fillings were not soluble in this solution. These were very old having always been left in the past. They had several layers of subsequent re-retouchings. Some of these could be mechanically removed with a scalpel, others had to be left and recorrected.

The picture was then relined by Anthony Reeve.

The old lining canvas was removed and the canvas was glue-lined and restretched on the old stretcher.

Blanching remained the problem. White spirit reversed it only momentarily. Varnishing reversed it for three days, after which it returned. Various tests were made to establish an effective method of reversing this blanching. Miniscule test areas were treated in turn with dimethylformamide, dammar, MS2A, mastic and a mixture of Cellosolve, diacetone alcohol and ethanol in the proportions 1:1:2, using a tiny brush and then varnished. In each case the blanching was initially reversed, but then returned within 3-4 days. A test was then made with a mixture of old viscous linseed stand oil and white spirit in the porportion 2:3 rubbed in on a small vertical strip at the bottom edge of the picture. In this way the blanching was reversed and did not return. It was decided that this procedure should be adopted for all the blanched areas. Oil was rubbed in with cotton wool wrapped in silk, taking care not to carry it into the sky or other unaffected parts. Nine weeks were allowed for observation before varnishing. The blanching after this procedure did not reappear. The affected parts regained their middle tones and intensity of colour. Unblanched shadows which had looked isolated and too dark regained their rightful meaning after treatment.

An isolating layer of MS2A varnish was then sprayed on. Inpainting was carried out using pigments ground in Paraloid B72 with xylene. Old retouchings and damages were matched in the upper left corner of the sky and in the sunset, the latter without re-enhancement, as previously. Small flake losses which were present before work began were filled with fine-surface Polyfilla and numerous retouchings made to cover them and old fillings. In the foreground darkened retouchings in the rock outcrop were lightened and exactly matched. Others were matched on the lower edge. An area of approximately 5 × 10 cm at the bottom edge almost in the middle remained very blue after stand oil treatment perhaps because of a yellow that had faded, rather than blanching. Only this area was re-glazed with colour. Also requiring some retouching were minor thinnesses in the mountain. On the trees behind the central figures the lichens were disturbingly light and did not follow the form of the trunk, perhaps because of a faded glaze. These were very slightly toned. Cracks were retouched where necessary. A final coat of MS2A resin varnish was sprayed on.

The picture is now in stable condition having been lined and stretcher keys secured by Anthony Reeve. Providing the blanching does not recur the restoration should last a considerable time. After cleaning the sky is paler and more airy, the sunset softer and more telling. The darks are more powerful and the trees more imposing. The recession has been regained.

Patrick Lindsay

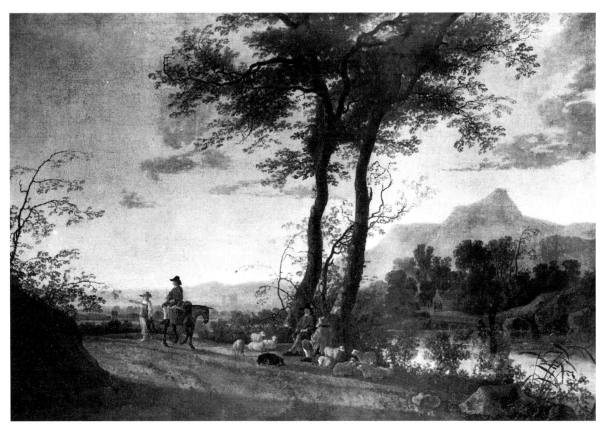

Fig.28 Before treatment.

10 Nicolaes Berchem (1620–1683)

A Farrier and Peasants near Roman Ruins

Canvas, relined 66.2 × 79.5 cm (stretcher size 67.2 × 81.2 cm)

DPG no.88

Bourgeois Bequest, 1811

The farrier shoes a mule, calmly observed by a most exquisite (and diminutive) bull, while a female peasant on horseback gestures, with a certain urgency, that the day is fading. The scene is set in the shadow of decaying Roman remains of long-forgotten purpose. The strong diagonal shadow cast across the central pier suggests an hour in the late afternoon, when the sun would be sinking fast.

The subject is not a particularly romantic one. The modern equivalent might be a car breakdown outside Colchester. But Berchem's peasants, though always active, and even anxious, lead their peripatetic life permanently in surroundings of the utmost serenity. They do not invite us to share in their tasks, nor to envy their lot, but they inhabit a world which is infinitely enviable.

No firm evidence has yet emerged that Berchem visited Italy, but his paintings seem to supply the proof. His landscape style was probably influenced by that of Jan Both, and possibly by Jan-Baptist Weenix who was his younger cousin and one of the artists under whom he is said to have trained. His work was highly appreciated in the eighteenth century and, along with Cuyp and Wouwermans, he was one of the Dutch landscape painters most favoured by Desenfans. The present picture seems to have been acquired at the anonymous sale (of J.P. van der Schley), held at Amsterdam, on 21 August 1799 (lot 15*).

CONSERVATION REPORT

Previous recorded treatment

Wood-worm in the stretcher and frame was treated with paraffin in 1936. The picture was treated by Hell in 1948–53.

Examination and Analysis

The original canvas is a plain-weave medium-weight linen. It had been glue/paste relined and at this time a 1.2 cm strip of filler was added at the left edge. The lining canvas was weak and brittle and beginning to tear at the edges.

The paint layers were lifting sharply in several areas and particularly around the edges. This problem had increased in recent years and, together with the weakness of the lining canvas, necessitated relining.

The ground preparation is a warm-brown colour composed of chalk, umbers and ochres with some lead white in large agglomerated particles, which may be a mixture of lead white and chalk. In the cross-section, the particle clusters appear loosely packed and fairly translucent. Lead white may have been added to assist the drying, but it was mixed in rather than being ground up thoroughly with the chalk and pigments.

The addition of lead white to the ground layer has created a granular texture and in places white particles seem to have burst through the surface, creating white dots. It is possible that lead white was added in order to texture the ground layer, but the eruption of lead white particles through the paint surface was clearly not intentional. This may have been caused by inadequate mixing of the lead white into the rest of the ground layer. The protrusions have also been abraded in previous cleaning.

Generally the paint layers are in very good condition with only a couple of small losses caused by previous flaking. Past cleanings have abraded the thinly painted brown areas. Earlier lining has also created some weave emphasis in the surface as well as a flattening of the impasto.

The blue hill has suffered some discolouration. A sample taken from this area shows a structure of three paint layers over the ground. The first layer is made up of colourless particles, probably decayed smalt. The odd vermilion particle is also present in this layer, but no white. The discolouration of this layer allows the brown ground to show through and this affects the tone and brightness of the layers above. The second layer contains ultramarine, lead white, vermilion and probably more smalt. The red may have been added to achieve the reddish blue of ultramarine. The third layer seems to contain ultramarine and lead white. The chemical change undergone by the smalt may have affected the medium of the layers above, and this may explain the blanched appearance of the top layers in the hills.

The sky contains a similar combination of pigments, but the smalt and ultramarine are mixed with larger quantities of lead white, creating a more chemically stable brilliant blue colour, which has not discoloured. Berchem probably added smalt because ultramarine was such an expensive pigment for seventeenth-century Dutch artists.

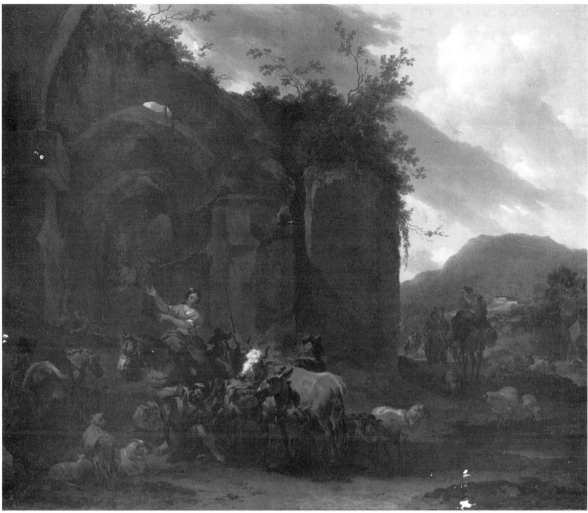

Fig.29 After cleaning, before restoration.

The thin varnish layer was discoloured and extremely opaque, making the brown areas difficult to read.

Treatment

The varnish was removed with a mixture of Propan-2-ol and 2.2.4 Trimethylpentane in the proportion 1:1. Retouchings were removed with Propan-2-ol except for one hardened retouching in the top right corner which was removed with a 2% ammonia solution (Fig.29).

The painting was faced and the lining canvas and glue removed by dry scraping. It was lined onto linen canvas with a paste lining adhesive containing pre-prepared bone glue (Croid Aero glue) mixed with water and plain wheat flour, to which a fungicide was added. A plain beeswax barrier was applied to the back of the lined canvas and the painting was stretched on a new stretcher.

Small tests were carried out to reduce the blanched appearance of the blue hills using a mixture of industrial methylated spirit, diacetone alcohol and cellosolve acetate in the proportion 4:1:1 and benzyl alcohol. Neither had any effect. Losses were filled with fine-surface Polyfilla (chalk/PVA) and an isolating layer of dammar varnish was applied prior to retouching. Retouchings to the abraded dark areas, to the largest and most disturbing of the white dots caused by the lead white clusters, and to the few losses were carried out using dry pigments in a Ketone N medium. A final coat of dammar varnish was sprayed on.

The treatment was fairly straightforward. Removal of the varnish made a dramatic difference because, although not excessively discoloured, the varnish had become very opaque and no longer saturated the browns. This flattened the illusion of depth in the architectural elements. Relining was necessary because of the embrittled and torn old lining canvas and because of the deteriorating adhesion of the ground and paint layers to the support. Glue/paste lining was chosen because a thoroughly impregnating lining was needed to hold down the paint and because the painting had already been glue/paste relined. Dammar was used for all the varnishing as it saturated the dark areas most effectively and Ketone N was used as the retouching medium since much of the retouching was in abraded transparent browns for which this medium is appropriate. The addition at the left edge was framed out.

11 Abraham Storck (1644–1708)

An English Yacht saluting a Dutch Man-of-War in the Port of Rotterdam

Canvas, relined 62.2 × 81.3 cm

Signed or inscribed (bottom centre): A. Storck

DPG no.608

Gift of Dr E. Warters, 1926

The picture shows the port of Rotterdam across the river Maas. In the centre is the church of Saint Lawrence. The prominent buildings on the left and right are probably intended to evoke the West and East New Gates, both built in the 1660s, and the East Old Gate of 1598, though they seem not to be wholly accurate. The two vessels in the foreground are a Dutch man-of-war on the left and an English yacht on the right. The man-of-war is flying the ensign of the States General of the Netherlands and the Dutch tricolour at the main. The flags together with the three lanterns on her tafferel indicate that she is the ship of a senior admiral. In two places on her stern she has a red lion rampant on gold, the arms of the Province of Holland. Men in the rigging are apparently taking in the sails as the vessel prepares to drop anchor. The English yacht must also be carrying a person of importance as she flies a Union Jack at her bowsprit and at the main the red flag with St George's cross in the canton which is the normal English ensign. She is firing a salute. In the distance are further ships: English in the centre and Dutch on the right. In the foreground a row-barge, about to land, has white swans painted on her bows and flies a red and white striped flag. Of the eight passengers, one is taking a drink.

The composition was repeated by Storck on several occasions with only the slightest variation of detail. The main difference between the Dulwich picture and other recorded versions is the omission of a dog in the foreground, centre left, but this may be the result of a damage. The popularity of the subject suggests that the event depicted is an important one, but it has yet to be firmly identified. It is evidently not, as has sometimes been suggested, the reception of the Duke of Marlborough at Amsterdam in 1704.

CONSERVATION REPORT

Previous recorded treatment

The picture was treated by Hell in 1953.

Examination

The lining canvas was stiff and had split along the left edge becoming detached from the stretcher. This was probably caused by too much glue in the lining which had become rigid and board-like putting additional strain on the tacking edges. The lack of tension had allowed the canvas to buckle resulting in an unsightly undulation in the surface (Fig.30). The other tacking edges of the lining canvas were also weak.

The overall ground is grey, but a paler underpaint was visible in the cracks and wear in the foreground area. There are lines of craquelure around the edges caused by the bars of an earlier stretcher and a pronounced craquelure in the foreground area, as well as cracks in the sky to the left of the upper sails and flag of the Dutch man-of-war and above the two distant Dutch ships on the far right. The weave pattern has been emphasised in the previous relining.

Overcleaning in the past has left the paint surface uneven and worn, in many areas through to the ground. The paint was probably also damaged by overheating during the previous lining. There are numerous old paint losses, especially in the foreground area, some filled with

Fig.30 Photograph taken in raking light before treatment.

a hard red filling material, others with gesso. The retouchings in the foreground area had darkened and there was further old overpaint on the stern of the man-of-war and on the large red flag on the right. In the sky there were several areas of pink-buff discoloured overpaint which did not correspond to the clouds. More recent feathered retouchings in the sky had blanched. The signature had been strengthened. The varnish was uneven and slightly discoloured.

56

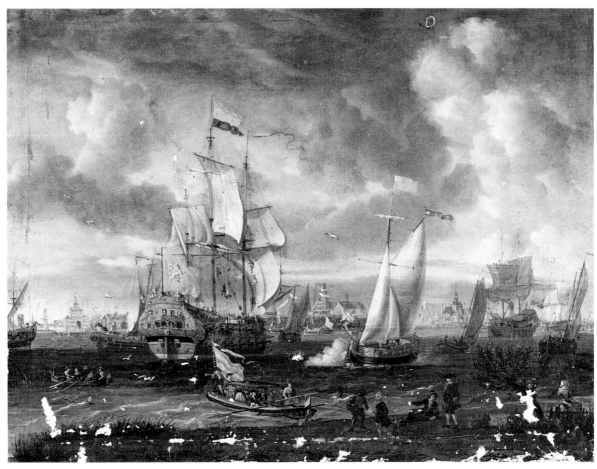

Fig.31 After cleaning, before restoration.

Treatment

The old, stiff lining canvas had to be replaced. Before relining the varnish and blanched feathered retouching were removed using a mixture of Acetone and white spirit in the proportion 2:1 and in places a mixture of Propan-2-ol and white spirit in the same proportion. The strengthening to the signature was not removed. Some of the uneven gesso fillings were removed by careful scraping with a scalpel under magnification. The hard red fillings proved stubborn and were mostly left. Cleaning tests on the old overpaint in the sky with a 2% solution of ammonia cleared with white spirit proved ineffective. It was not possible to remove this overpaint without risk to the already abraded original paint and the overpaint was therefore left (Fig.31).

The old lining was then removed and the painting was relined on linen canvas using Beva 371 adhesive and restretched on the old stretcher. When removed from the old lining the canvas was able to 'relax' and flatten out.

The unfilled old paint losses were then filled using fine-surface Polyfilla and an isolating layer of dammar varnish was brushed on. A grey ground colour was then applied to the fillings with pigments ground in Paraloid B72. Further retouchings were carried out with pigments ground in Laropal K80: the final layers were inpainted on the filled losses, the most disturbing cracks in the sky were subdued, along with the remaining overpaint and the more noticeable areas of abrasion. A final dammar varnish was sprayed on.

The paint surface has been damaged significantly with areas of loss, cracks, abrasion and overpaint. The inpainting was carried out to a level where these damages are subdued and do not distract from the form and recession, especially in the sky. However, it can still be seen on close inspection that the painting has suffered and that the paint surface has been abraded.

57

12 Thomas Gainsborough (1727–1788)

Mrs Elizabeth Moody and her two Sons

Canvas, relined, 234 × 154.2 cm.

DPG no.316

Gift of Captain Thomas Moody, 1831

Fig.32 John Russell (1745–1806), *Samuel Moody*, pastel on paper, 60.3 × 44.8 cm. Dulwich Picture Gallery (no.601).

This portrait of a young mother and her children stepping out in a landscape setting, datable c.1779–80, is a good example of the artist's work of the late 1770s. His distinctive brushwork and harmonious colour combinations are obvious, as is the elegance of the sitter, who has slightly elongated proportions. All, however, is not quite as it appears in this portrait and art historians have for some time viewed it with puzzlement.

The sitter is Elizabeth Moody (*née* Johnson), the daughter of Thomas Johnson of St Ives, Huntingdonshire. She was born in 1756 and on 15 April 1779 she married Samuel Moody of Queen Square, London and Bury St Edmunds in Suffolk (see Fig.32). He was over twenty years her senior and little is known of his family. Tragically, in December 1782, only three and a half years after her marriage, she died of tuberculosis while receiving the 'cure' at Bristol Hot Wells, leaving two infant sons. She is commemorated by a tablet in the aisle of Bristol Cathedral. At the time of her death her children, Samuel (born 24 April 1781) and Thomas (born 10 May 1782) were respectively 20 months and 8 months old. It is here that the mystery begins for the two lively boys in the present painting, the younger with red hair being carried by his mother and the other blonde boy walking at her side, are clearly toddlers, aged about two and a half and three and a half. They are certainly not babies.

For many years the painting was dated to the last years of Mrs Moody's life to account for the fact that she was portrayed with her children. The children have erroneously also been called girls rather than boys, presumably because they wear pink sashes. Their costumes, however, are entirely consistent with boys' attire of this period. The painting itself is also stylistically a work of the late 1770s and has always been recognised as such, and both Mrs Moody's quasi-Turkish dress and her hair-style clearly also date the work to that period. The mystery baffled such earlier cataloguers as Peter Murray whose notes on the subject in the history file at the Gallery are extensive.

The numerous and increasingly visible *pentimenti* around the figures of the children aroused the suspicion that they might have been added later and, in 1989, X-rays of the painting revealed that such suspicions were well founded (Fig.36). It became evident that the two children were added later, presumably at the request of Samuel Moody about two years after his wife's death. It was not unusual for Gainsborough to have a portrait returned to him some years after its completion. *The Linley Sisters*, also at Dulwich, was painted in 1772, but returned to the artist in 1785 to be 'improved and freshened up'. A technical examination of the painting, discussed below, revealed that Mrs Moody was originally painted alone with her right hand up to her neck fingering a pearl necklace. It seems likely that, since she was married in 1779, the work would have been painted to celebrate this occasion. These additions explain her slightly clumsy right hand supporting her younger son. The children are sympathetically painted and it can only be imagined that the artist found the addition of these motherless boys to a portrait of their dead parent particularly poignant.

Samuel Moody was married again in 1786 to a Miss Mary Paterson, by whom he had a further four children. On his death in 1808 he bequeathed this portrait to his younger son – the charming red-haired boy with dark eyes and red slippers – by then Captain Thomas Moody of the 41st Foot. He presented the portrait of his mother to the Gallery in 1831. It is not entirely clear whether he had any connections with Dulwich College or the Gallery. There appears to have been no obvious reason for his generous gift, other than the fact that Dulwich was one of the

very few galleries open to visitors at the time, and was already known for its outstanding Gainsboroughs of the Linley family.

Some years later in 1915, a grand-daughter of Samuel Moody's second marriage, a Miss Sylvester, died and from her property, the art dealers, Leggatt Brothers, acquired an accomplished pastel portrait of Samuel Moody by the Guildford artist John Russell (Fig.32) and a portrait of his second wife Mary Paterson. These were offered to Dulwich Picture Gallery and the pastel was acquired by the then Curator, H. Yates Thompson, who gave it to the Gallery in 1917. The portrait of Mary Paterson was not acquired, so we cannot today compare her directly with the first Mrs Moody with her striking, prominent features. The recent conservation of the work has revealed the luminous colours of this portrait and encouraged further research into the painting's fascinating history.

Ann Sumner

CONSERVATION REPORT

Previous recorded treatment

The painting was cleaned and varnished in 1914. In 1934 signs of wood-worm were noted in the stretcher. The picture was treated by Hell, c.1951–March 1953.

Examination and analysis

The canvas has been relined. The original canvas and lining remain sound and the ground and paint layers are stable.

Generally the painting is in very good condition. There are a few small losses at the very top of the picture in the foliage of the tree and some wear in the landscape to the right of the standing child. There are horizontal cracks caused by a previous stretcher, especially noticeable on the left side in the body of the child.

The painting, however, was difficult to read owing to certain consequences of Gainsborough's technique, exacerbated by obscuring layers of yellow varnish. Thus in many areas the painting has a pronounced craquelure which is in some places very wide and in others slightly raised at the edges. Discoloured varnish had accumulated within the craquelure causing the lines to darken and these dark lines crossing the forms had the effect of disrupting and flattening perspective and volume (Fig.33).

Numerous *pentimenti* are visible in Mrs Moody's dress, hair and feet and in the two children. These *pentimenti* have become more visible as the paint becomes more transparent with age and they significantly confused the image; Mrs Moody, for example, appeared to have three feet (Fig.35).

The extent of the *pentimenti* is accounted for partly by the fact that Mrs Moody was originally painted alone, her two children only being added later. Some of the underlying brushstrokes can be seen in the paint surface. This was especially clear in a photograph taken in raking light which shows brushstrokes underlying the children corresponding, in the one case, to Mrs. Moody's original right forearm and, in the other, to the original lower right portion of her dress. The X-ray

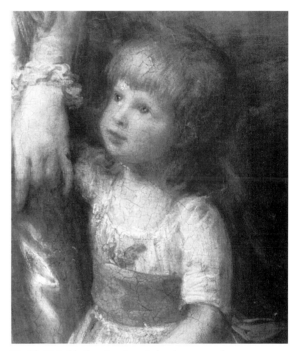

Fig.33 Detail before treatment showing craquelure.

confirms that Mrs Moody's right hand was originally at her chest and fingering a string of pearls, which has been painted out, and shows bold brushwork under the standing child (Fig.34). The whole area of the standing child and the area above the child's head to the right of Mrs Moody's hip were originally filled with drapery more solidly painted than that currently visible behind the standing child.

Apart from the craquelure and *pentimenti* the appearance of the painting has changed in certain other respects with age. The picture has generally darkened because the dark underpainting now exerts a greater influence owing to the increased transparency of the upper layers. At the same time the sky has also become darker and duller owing to changes in the pigment, which is probably Prussian blue, a pigment now known to exhibit

Fig.34 X-radiograph assembly.

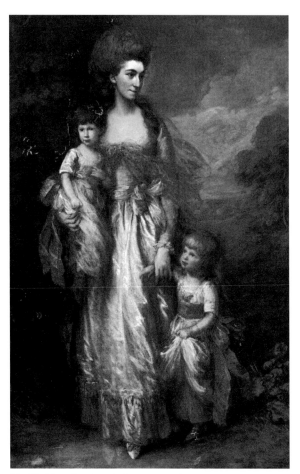

Fig.35 After cleaning, before restoration.

such changes. An area of blue sky which has been protected from light by the rebate of the frame shows the extent of this change. Mrs Moody's face and chest, which are more solidly painted, now appear by contrast slightly too pale in tone.

Treatment

The painting was surface cleaned with a weak solution of deionised water and Metapex detergent cleared with deionised water. The varnish was removed with a mixture of industrial methylated spirit and white spirit in the proportion 1:5. Special attention was paid to the varnish caught around the craquelure and this was removed with a brush and by gentle scraping with a scalpel. There were very few retouchings, but in a few places the cracks had been touched out. These retouchings had discoloured and were removed with the same mixture as was used to remove the varnish. An isolating layer of MS2A resin varnish dissolved in white spirit was then brushed on (Fig.35).

Some of the disfiguring wide cracks of the craquelure were filled with gelatin and chalk filler, as were the losses. The restoration was carried out using pigments bound in egg tempera and in MS2A for the glazes. It was necessary to suppress

judiciously the most disturbing craquelure and elements of the *pentimenti* in order to recover the recession of the landscape and sky and the clarity of form. The painting was finally sprayed with several thin layers of MS2A resin varnish, the final layer containing a small proportion of Cosmolloid 80H wax.

The cleaning of *Mrs Moody and her two Sons* was relatively straight forward. Removal of the thick yellow varnish made it possible to distinguish such subtle colour differences as the various greens in the leafy landscape and between the blues and purplish greys of Mrs Moody's jacket, her diaphanous shawl and the clouds and sky behind it. The three figures are now seen to be dressed in garments of graded whites rather than yellow and the children's sashes, rather than the hot orangey colour which they assumed when uncleaned, have regained their delicate shades of pink. It was necessary to suppress some of the *pentimenti* and cracks which confused the image, but retouching was taken only far enough to ensure that the figures emerged as convincing forms situated comfortably in the landscape. Much of the extensive network of craquelure and the evidence of alterations remain, attesting to the age of the painting and its unusual evolution.

Glossary

Abrasion
The rubbing away or minute scratching of the painting's surface, causing wear, which can be disfiguring.

Azurite
A mineral *pigment* derived from basic copper carbonate, which is blue or blue-green according to its source, and is a less pure blue than *ultramarine*.

Blanching
A term used to describe the pale, milky appearance which can affect either the paint or *varnish* layers. It is especially common in Dutch seventeenth-century green *pigments*. Its causes are varied, usually chemical, and are not always fully understood.

Blooming
The bluish, cloudy appearance of the surface of aged *varnish* caused by minute cracks which diffuse light.

Bone black
A black *pigment* made from burnt, carbonised bone, which gives a warmer black than wood charcoal.

Canvas
The linen fabric, made from hemp or flax, traditionally used as a surface on which to apply paint. There are various different types and qualities of canvas weave, for example, plain (tabby) and twill.

Cassel earth (Van Dyke brown)
A warm, reddish-brown *earth pigment* derived from lignite (brown coal) containing a high proportion of organic material, and some iron oxide.

Cleaning
The term is commonly used in painting conservation to mean the removal of old, dirty, yellowed *varnish* or old restorations, either chemically dissolving them with an appropriate *solvent*, or mechanically. See also *surface cleaning*.

Craquelure/Crazing
The appearance of networks of small cracks, caused by a number of factors, especially the ageing of the *medium*, and too much movement of the *support*. Craquelure can be disfiguring, and may result in flaking and *cupping*.

Cross-section analysis
A method of examining the layer structure of paint in a specific area of a painting. A minute sample is taken and set in a block of cold-setting resin, which is then ground and polished to reveal the edge of the sample for examination under a microscope. *Pigments* can be identified by their colour and optical properties, and further analysis can be carried out, e.g. by *EDX*.

Cupping
Cupping describes a state where the edges of the *craquelure* become detached and raised, creating uneven concave craters in the paint surface, with the risk of flakes of paint becoming lost. This can be very disfiguring.

Cusping
The undulating, or scallop-shaped distortions in the weave at the edges of a *canvas* where it is first attached to a *strainer* or *stretcher*. See also *tacking edges*.

Dye
A colouring matter which is used in solution as a stain, as opposed to a *pigment* which is suspended in the *medium* for painting. Dyes may be derived from natural sources, though the majority are now synthetic. See also *lake*.

Earth pigments
Natural *pigments* consisting of a mixture of clay and various iron oxides in different proportions, and other substances. They are yellow, red, brown or even black in colour. See also *ochre*, *umber*.

Energy-dispersive X-ray microanalysis (EDX)
Using the *scanning electron microscope*, a beam of electrons falls on a paint sample and generates X-rays, whose energy levels vary according to the elements in the sample. The instrument measures energies and assigns them on a visual display to the elements in the sample. From this data, it is possible to deduce what the component *pigments* are.

Facing
A method of supporting the front (image) of a painting while it is being treated, especially during *relining*. A sheet, normally of tissue, is laid over the image and attached with a weak solution of adhesive, to ensure that no paint flakes or weak areas are lost or damaged during treatment, and is removed after treatment by redissolving the adhesive.

Gesso
Traditionally gesso is prepared from burnt gypsum (plaster of Paris) and *glue*. It was commonly

used as a *ground* preparation on *panel* and occasionally on *canvas*. It is also used as a material for filling losses.

Glaze
Generally, a term used to describe a thin, transparent paint layer which can be used to modify or enhance the colour of the paint below.

Glue
An adhesive consisting largely of gelatin, or other proteinous material, though generally a nearly pure gelatin is termed 'size'. Cf. *paste*.

Ground
The preparatory layer, or layers, applied to the *support* to provide a surface on which to paint. Various materials are used, e.g. *gesso* and red *ochre*, which give different hues to the painting.

Impasto
Thickly applied paint which stands out in relief from the surface.

Infra-red
Infra-red is the part of the spectrum below visible light, and its longer wavelengths can penetrate visually opaque media. *Pigments* which absorb infra-red strongly are ones based on carbon (graphite pencils, charcoal, black chalk) and *earth pigments*, so underdrawing and *ground* layers can be revealed when viewed or photographed under infra-red light.

Inpainting
The restoration or *retouching* of paint losses, applied without overlapping any of the original paint. An isolating film of *varnish* is applied between the original and the inpainting, which thus remains easily removable.

Isinglass
An adhesive made of gelatin derived from the swim bladders of fish.

Lake
A *pigment* made by precipitating a *dye* solution onto a base or substrate. Solid particles are thus formed, which are coloured by the *dye*. Lakes may be red, yellow, reddish brown or yellowish brown, and are generally transparent pigments when mixed with the paint *medium*; they are often used as *glazes*.

Leaching
The effect by which components of the paint *medium* are drawn out of the paint structure by *solvents* used in *cleaning*, or by moisture used in certain *lining* processes.

Lead white
A mineral *pigment* prepared from basic lead carbonate to produce an opaque white.

Lead-tin yellow
An opaque yellow *pigment* made by heating lead or a lead compound with stannic (tin) oxide; the shade depends on the temperature of preparation.

Lining
A secondary *canvas support* stuck to the back of the original canvas to reinforce it. It is often necessary to reline a painting when the lining becomes fragile or if it is putting the original canvas under strain.

Malachite
A bright green mineral *pigment* derived from basic copper carbonate, similar to, and often found with, the blue basic copper carbonate, *azurite*.

Medium
Medium is the term usually applied to the binding material or vehicle that holds together *pigment* particles in paint, forming a coloured film or layer. See *oil, tempera*.

Ochre
A natural *earth pigment* of varying shades, from dull, pale yellow, to reddish brown, depending on the water content.

Oil
The oils used in oil paint are drying oils – oils which dry naturally in air – such as linseed, walnut and poppy seed oil. The oil *medium* is liable to chemical changes as it ages, resulting in yellowing, cracking and disintegration. Drying oils can be processed to lessen such deterioration, by heating them without oxygen, to produce a viscous, clear oil, called stand oil.

Panel
A rigid painting *support*, usually made from planks of wood.

Paste
An adhesive which is starch-based, usually made of wheat, rice or potato flour. Cf. *glue*.

Pentimento
An alteration made by the artist to an area already painted. These can become visible as the paint becomes more transparent with age.

Pigments
Substances which, in the form of particles or grains, are suspended in a *medium* to provide the colouring material in paint. They are derived from a variety of substances, organic and inorganic, natural and artificial, and thus have different physical and chemical properties.

Priming
A thin, continuous layer of *medium* applied to the basic *ground*, often with a *pigment* content, preparatory to painting.

Prussian blue

The earliest of modern synthetic colours, introduced c.1720. Based on ferric ferrocyanide, it is a deep transparent blue *pigment* with a high tinting strength.

Raking light

A method of examining a painting by directing light onto the surface at an oblique angle, thus creating strong shadows and revealing the surface details.

Retouching

Paint applied by restorers to cover losses or degraded areas. In earlier restorations, the retouchings often overlapped the original paint. Old retouchings tend to discolour at a different rate from the original, and can be very disfiguring. In modern conservation practice, the term is often synonymous with *inpainting*.

Scanning electron microscopy (SEM)

This method of examination provides a much greater magnification than conventional microscopes. A beam of electrons scans the sample, and the electrons scattered by the surface are collected and used to generate a video image. Thus the surface and three dimensional structure of the sample are revealed at magnifications up to 100,000×, though the image can only be seen in black and white.

Smalt

Potassium glass coloured blue with cobalt and powdered to make a pale *pigment*.

Solvents

Any liquid in which a substance dissolves. Water is the most common solvent. However, the term is generally used to describe the volatile organic compounds, including spirits and alcohols, which dissolve substances that are insoluble in water.

Stand oil

See *Oil*.

Strainer

A fixed wooden frame onto which a *canvas* can be laced or tacked.

Stretcher

The adjustable wooden frame to which, since the eighteenth century, a *canvas* is normally attached to keep it taut. The stretcher is so jointed that small wedges (keys) can be inserted in the corners to slightly expand the outside dimension and tauten the fabric. Cf. *strainer*.

Support

The physical structure onto which the *ground* and paint layers are applied. See *canvas, panel*.

Surface cleaning

The removal of dirt and accretions from the surface of the *varnish* layer.

Tacking edges/margins

The edges of the *canvas* which are folded over and attached to the *stretcher*, usually by means of small tacks. Examination of the tacking edges can reveal information about the *canvas*, and about the *ground* and paint layers. Original tacking edges have frequently been removed in the process of *relining*.

Tempera

An egg yolk *medium*.

Ultramarine

A pure blue natural *pigment* extracted from the semi-precious stone lapis lazuli.

Ultra-violet

A form of radiation just above the visible spectrum. Some substances, when illuminated with ultra-violet, fluoresce (reflect visible light) revealing details not otherwise visible, such as *retouchings*.

Umber

An *earth pigment* containing black manganese dioxide, giving it a dark brown colour. It may be used as it is, 'raw', or 'burnt' (heated), which makes the colour warmer.

Varnish

A picture varnish is a transparent, protective layer applied over the paint film, made traditionally with a natural resin dissolved in a *solvent*. Modern varnishes employed in conservation contain synthetic resins which discolour very little.

Vermilion

A red *pigment* consisting of mercuric sulphide, traditionally found in nature as the mineral cinnabar, but now usually synthetic.

X-ray

A form of radiation above both the visible light and ultra-violet region of the spectrum, whose short, energetic wavelengths penetrate the painting except when blocked by dense *pigments*, in particular lead white. Such *pigments* show up lighter on an X-ray image (X-radiograph) in proportion to their density and the thickness of the layer.

Conserving Old Masters

Dulwich Picture Gallery, 22 June 1995–10 September 1995

Exhibition sponsored by
the Getty Grant Program

Catalogue edited by
Richard Beresford and Giles Waterfield

Designed by Barry Viney

© Dulwich Picture Gallery, London, 1995

Photoset and printed in England by
The Lavenham Press, Water Street,
Lavenham, Suffolk, CO10 9RN

ISBN 1 898 519 06 4

Cover: Rubens, *Venus, Mars and Cupid*
After conservation
Back cover: Cuyp, *Herdsmen with Cows*, detail before and after
treatment.